ART TECHNIQUES FROM PENCIL TO PAINT

SKETCH & COLOR

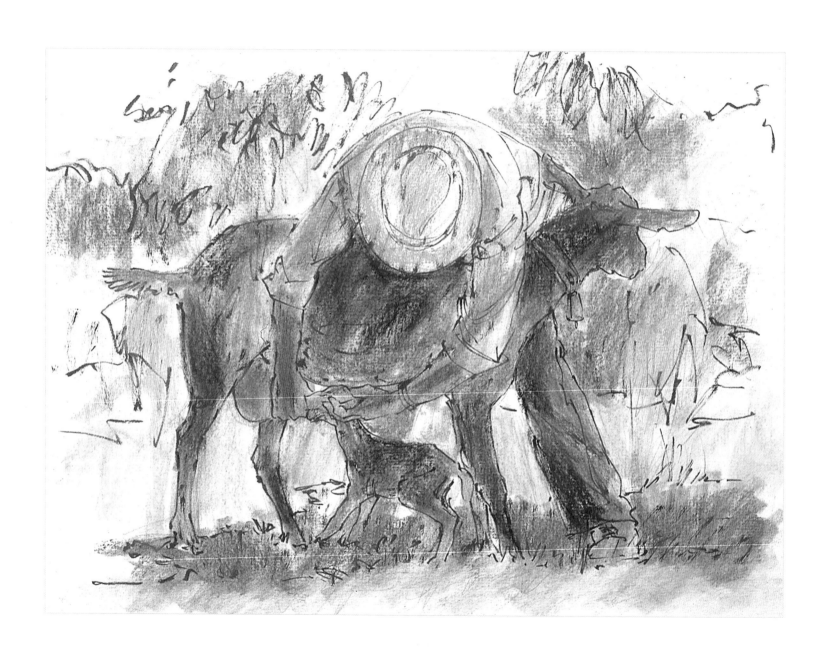

ART TECHNIQUES FROM PENCIL TO PAINT

SKETCH & COLOR

PAUL TAGGART

Sterling Publishing Co., Inc.
New York

Concept, text, illustrations and photographs © Paul W. Taggart 2002

Paul Taggart has asserted his rights to be identified as the author and illustrator of this work

Series concept and structure by Eileen Tunnell

© TAJ Books Ltd 2002

Library of Congress Cataloging-in-Publication Data Available

10 9 8 7 6 5 4 3 2 1

Published in 2003 by Sterling Publishing Co., Inc.

387 Park Avenue South

New York, NY 10016

First published in Great Britain in 2002 by TAJ Books Ltd.

27 Ferndown Gardens

Cobham, Surrey, KT11 2BH

©2002 by TAJ Books Ltd.

Distributed in Canada by Sterling Publishing

C/o Canadian Manda Group

One Atlantic Avenue, Suite 105

Toronto, Ontario, M6K 3E7, Canada

Sterling ISBN 1-4027-0226-4

CONTENTS

What exactly is a sketch and how does it differ from a drawing?

A sketch is an impression that is used to gather and collate information. I see gathering information as sketching carried out in a live situation, whether it be in a landscape or working from a still life. To collate information is to pull together various elements from other source material with which to put together a composition.

You may be considering more finished work, such as a drawing or a painting and deciding what elements are required, or you may simply be recording a fleeting moment just for the fun of it.

The sketches being created will enable you to coalesce ideas and bring them into focus. They will enable you to observe the structure before getting too involved in the detail.

In other words, sketching is a way of helping you to look below the surface of your subject, examine its structure, and make notes to be utilized or re-examined in the future.

A sketch is not necessarily the end of the search; it may simply be the means to an end.

Since there are no expectations as would be felt in producing a more finished work, there is no need to approach sketching in a formal manner. While a sense of purpose is required, the sketch should be tackled in a relaxed way.

Because of the freedom that a sketch engenders, it can be more beautiful than a highly crafted piece of work. Look at the sketches of great Masters such as Van Gogh, Constable, or Turner who reflected the impromptu settings in which they found themselves working. These are often much more dynamic and exciting than the paintings subsequently produced of the same subject.

There is undoubtedly something unique about sketching on the spot. When working from a photograph the information is limited. Only a small percentage of the colors and values are captured, especially in shadows. Working 'en plein air' — as it is known — allows you to see these, as it does your eyes to roam, selecting other elements outside your immediate view to be incorporated into the composition. After all, what benefit is artistic licence if you cannot manipulate the scene to enhance it? Sketching live subjects brings with it a certain time restriction, which forces you to make fast, dynamic decisions that often make the composition work better.

Should sketching live subjects not be for you, why not turn to reference material and work indoors. Spread out your sketching materials and references, place a sheet of cartridge paper on the table, pick up a pencil, and let your hand roam freely across the surface. Do not restrict yourself and soon the ideas will start to form — you are on a voyage of discovery.

Think of the sketch as preparation, an experiment that will develop into an idea. Continually remind yourself that you are sketching, not drawing or painting. Suddenly you will begin to enjoy the experience and not worry about the finished results. From this point on, you will be pushing out your own boundaries and learning in the process.

Keep a sketchbook, for years later the visual jottings may well inspire you to produce a wonderful painting. Sadly this obvious advice is all too often ignored, and so many experience the frustration of remembering missed subjects, all too many of which will have long since disappeared. Furthermore, by keeping a sketchbook, you can look back through them over time and discover the joy of seeing how you have progressed from your early beginnings in learning to sketch, draw, and paint. Do not be tempted to produce complete drawings in these; use them to freely express your ideas by keeping the sketches loose.

I, for one, misunderstood this simple direction from tutors when attending Art College, and as a consequence my early sketchbooks were full of clean pages, neatly filled with detailed drawings. It didn't take long for the message to get through however, and my large collection of sketchbooks is now filled with pages containing jottings, scribbles and sketches. The pages have become smudged and coffee stained, testimony to the fact that they are well-thumbed and constantly referred to.

They come into their own particularly for capturing life studies, where the subject cannot be relied on to sit for any length of time. Be it pet, a child, an adult on the move, making a series of quick sketches will tell you so much more about the subject because it forces you to observe them closely.

Sketchbooks should be used as visual scrapbooks in which to record jottings, ideas for future inspiration, and captured moments.

Another approach, one that is more unique, is to create an Artists' Book, a visual journal in which to make a sketched record for posterity — something that can be handed down to future generations.

It is the approach to the materials and mindset of the artist that governs the execution. The following step-by-step workshops offer you the opportunity to explore a wide range of sketching methods and materials. They are intended to provide you with a good grounding from which to expand and develop new approaches.

Sketching with Color uses the simplest of materials to complete the simplest of still life studies, covering a variety of techniques, executions, and materials and finishing with a flower study in mixed media. Some of the techniques will come as a suprise to you for being associated with sketching; others will not.

You may wish to explore the world of sketching with color in its own right and stay in it for some while, or better still, use this book as the stepping stone into the world of painting where you will be working with brush and color.

In whatever form it takes,
sketching is in of itself a work
of art, be it a simple one
completed with a ballpoint pen,
scribbled onto the back
of an old envelope, or with the
best quality paints.

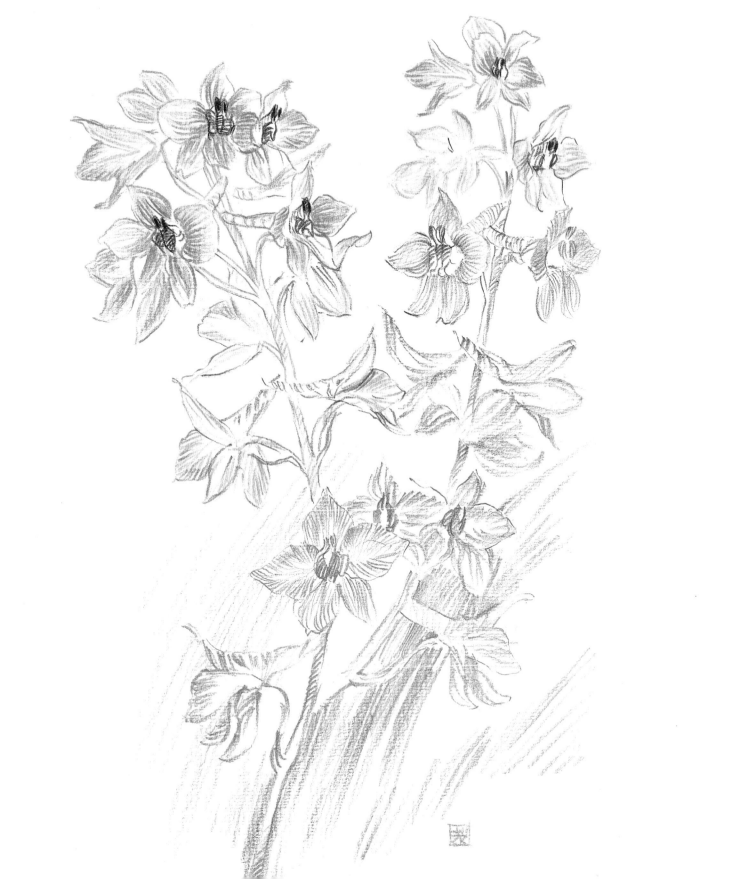

PENCILS

Introduction

At a very tender age, I was given my first set of colored pencils. Jealously, I guarded the tin, ensuring that each pencil was constantly pointed and the colors were laid out in the order of the spectrum. They were never left lying around, nor were they allowed to fall on the floor, and my only frustration came when the pencils gradually diminished in length. I haven't changed much, for buying a new set of pencils is always a joy — especially the scent of the new wood.

Colored pencils make an ideal stepping-stone into using color for the first time. They offer all the control of an ordinary graphite pencil and are easily erased. Unlike other colored painting media, they can be produced on easily obtained cheap surfaces and are simple to transport in your pocket or bag. You must, however, appreciate their differences in order to maximize their full potential.

As with ordinary pencils, they are slow, requiring gradual build up, and it is, therefore, advisable to use them for an appropriate subject. For sketching or creating small finished pieces, colored pencils are unsurpassed. For larger, heavier rendering, it is well worth considering mixing them with compatible media, such as crayons, watercolor pencils, or pastels.

Used in conjunction with watercolor or acrylic paints, they can be used to provide the detail, against which to work the swifter washes of color.

The making of colored pencils is in of itself an art, all elements of which when brought together successfully bring us a tool that is a dream to use.

We simply pick them up and use them, often unaware that the type of wood used for the shaft is balanced against the softness of the lead. If the wood is of a poor quality, then effective sharpening is made difficult.

Glue used inside the pencil shaft can help to prevent snapping if the pencil is dropped. Even the paint used for coating the shaft may have been designed to prevent cracking.

For the exercise in the following workshop, the subject has been kept simple, to enable you to achieve a result in a sensible time scale. This is not to mean that you should not attempt something more challenging.

If you enjoy the slow build and ultimate control to be found with using the colored pencil, then nothing should stop you exploring the medium further. You must however, be prepared to give it the time it will undoubtedly require.

If working in this medium suits your nature, thenby all means stay with it for as long as you are gaining satisfaction and increasing your confidence with the use of color.

Start by either copying the following exercise, or set up your own simple still life using the same steps. You will learn much by observing and rendering objects with differing colors and textures. How different do the pencil strokes need to be in order to capture a feather or flower, a rock or a shell? Select objects that can be left safely and returned to as you get the time and inclination to come back to the work in progress.

Materials

1. Tin of Artists' Quality Colored Pencils
2. Cartridge Paper
3. Bristol Board
4. Hot Pressed Watercolor Paper
5. Pencil Sharpener
6. Scalpel or Craft Knife for Sharpening
7. Kneadable Putty Eraser
8. Compressed Paper Wipers
9. Rolled Paper Wiper
10. Sandpaper Block for cleaning and sharpening compressed paper wiper
11. Acetate for masking
12. Proprietary Thinners for dissolving pencil strokes
13. Correction Markers for dissolving pencil strokes
14. Brush for blending or wiping dissolved pigment
15. Smooth Support Board for paper

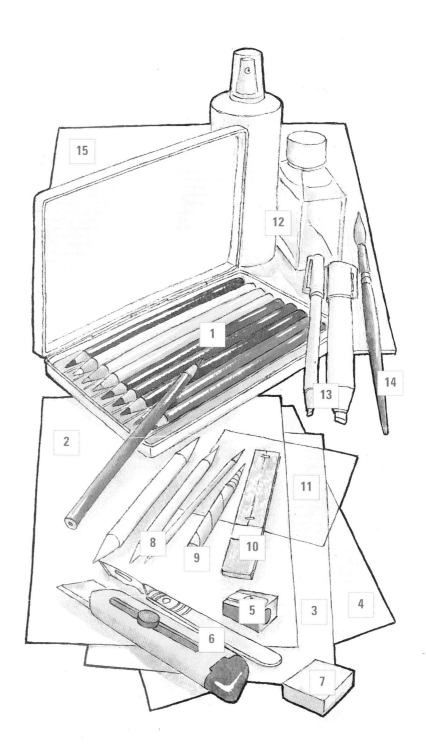

Surface Color Mixing

When first starting out with colored pencils or working outdoors, you will probably be doing so with quite a limited palette. Colors, however, can be mixed on the surface to extend your color range. While pencil does not blend in the same manner as paint, it can, nevertheless, be built in layers, or colors laid so closely that they mix visually on the surface. This visual color mixing can be successfully achieved with pencil in several ways.

[1] Lines of color laid next to one another as hatching or [2] laid over one another as cross-hatching. In both cases, the pencil is applied from the point [3] with pencil held at a steep angle to the paper. [4] & [5] show the two colors used to achieve the mix in [1] and [2].

While the use of hatching and cross-hatching develops texture, shading picks out the texture of the surface [6]. The pencil drawn much closer to the paper surface skates across the paper fibers, coloring those that protrude [7]. It is an advantage when shading to expose a long point on your pencil so that it can be held at this much flatter angle. [8] shows the two colors used to achieve the mix in [6].

NOTE
When shading, ensure the surface beneath your paper is perfectly smooth, or you may inadvertently produce a rubbing of whatever texture is beneath.

TIP
Combining colored pencil and watercolor can be a great advantage. The pencil does not dissolve in the watercolor washes; hence it can be used under or over the watercolor layer — something worth trying out.

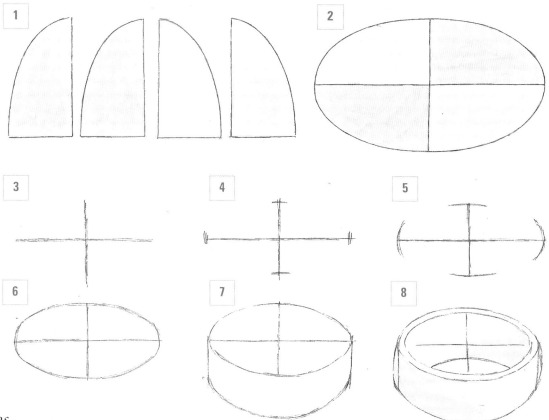

Hints & Tips

DRAWING ELLIPSES FREEHAND
Ellipses turn up again and again in drawing and painting, from bottles to wheels and from railway arches to portholes. They cause so much frustration and yet are really quite simple to get to grips with, once you know what to look for in their construction. All ellipses can be split into four equal segments, like pieces of a pie [1]. Where these pieces meet, a cross is created [2].

To start an ellipse, commence with this cross, extending its height and width [3]. Mark off a length on the height (top) and an equal length on the depth (bottom) that corresponds to the overall height of the ellipse of the object. Repeat this on the width, corresponding to the width of the object. Ensure that the height is in correct proportion to the width [4]. Make a simple curved mark across each of the four points

[5]. To complete this flattened stage of the ellipse, join the curved marks together [6].

The principle is identical for the bangles used as the still life study in the following exercise. To complete the bangle shape, drop two parallel lines down from the left and right points on the width [7] and join with a curved line that generally follows the same line as the bottom curve of the ellipse

above. Complete by adding the back of the bangle, the top of the lower ellipse [8].

MATERIALS
Tin Artists' Quality Colored Pencils
Good Quality Cartridge or Drawing Paper
Large Paper Wiper
Kneadable Putty Eraser

Step 1

Light blue is the preferable color with which to start your colored drawing. Blue always recedes and will be easily covered by subsequent, heavier linework, especially if you keep its application gentle and sketchy. Although objects of this nature have a hard consistency, they should not have a hard edge all round. Softness suggests depth, so keep your lines like a spider's web until the silhouettes and structure begin to emerge. Gentle line, such as this, can easily be erased, and it is at this stage that large changes can be easily accommodated. Keep the pencil point sharp so that hardly any pressure is required to register a line.

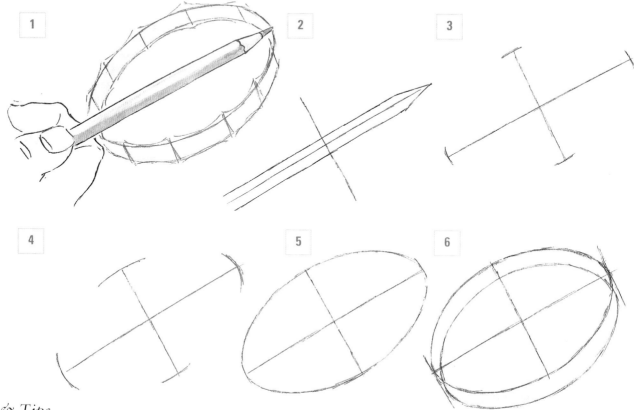

Hints & Tips

DRAWING ELLIPSES FREEHAND
(CONTINUED)
Not all ellipses lie flat, and this creates the greatest confusion of all. However, their construction is exactly the same as before. All you have to do is observe at what angle the ellipse lies. To do this, hold a pencil in front of the ellipse and rotate until it cuts the ellipse into two equal halves [1]. Think of this as the hands of a clock (in this case the bangle lies at 2 0'clock) [2], with the angle

being the longer axis of the ellipse. Draw the shorter axis at right angles to it and mark off equal distances from the center as before [3]. Continue through [4] and [5] as before, noting that the depth of this bangle is slightly shallower than the other [6]. Mark the scallops along the edge as in [1].

NOTE
In Step 1 these construction lines are gently drawn and then mostly erased so that only the soft outlines of the bangles remain.

Step 2

With a dark green, sharpen the silhouettes. Use a descriptive line and begin hatched values (shading). The skeleton created in Step 1 is an invaluable guide, but now is the time to make any large corrections that may be necessary (note changes to the ellipse of the larger bangle). Gentle pink directional hatching establishes the surface on which the bangles sit. Yellow-green hatching to the bangles begins to solidify their form. Use a kneadable putty eraser where necessary to both remove earlier construction lines and generally keep the drawing clean.

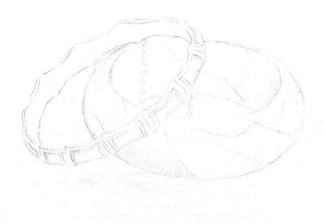

Step 3

Solidify the table's surface using dark blue hatching and cross-hatching in the shadows cast by the bangles. The reflective surfaces within the bangles begin to emerge with contrast, constructed using stronger hatching. There is a terrible temptation at this point to finish off or complete the areas that you are beginning to enjoy. However, the drawing must be balanced, so move swiftly through the whole drawing, holding back on the stronger darks and sharp detail.

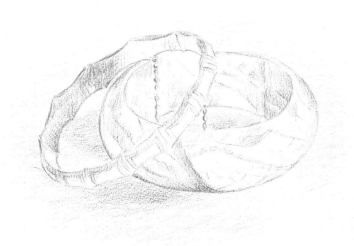

ARTSTRIPS

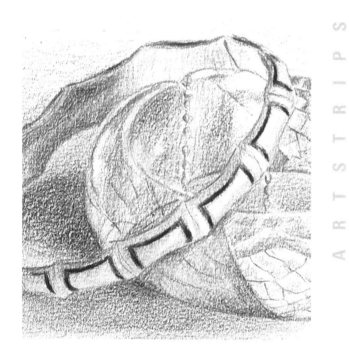

Use compressed paper wiper to blend. Always use clean smooth shoulder of wiper tip.

When this becomes distressed, blunted or soiled...

...do not use knife or pencil sharpener to restore.

Sharpen and clean on sandpaper. Sanding-block made for pointing pencils is ideal.

Step 4

Use a clean paper wiper to soften and spread the pigment. This fills in some of the harsh white paper between pencil strokes while still retaining the natural textural quality of the pencil. Although it is inevitable that a little detail is lost in softening the image, it is always an advantage to be able to keep early stages of any piece soft in focus. You can now begin to sharpen areas that you feel to be of more importance, leaving other sections visible but undemanding of detailed examination. Partial erasing with a kneadable putty eraser softens the edges of the vignette background.

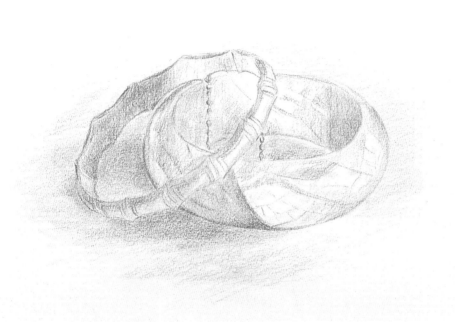

Step 5

Having achieved a soft structure, you can now begin to enjoy placing these sharp exciting details. Dark blue accents to the rectangular pattern of the top bangle are just such an example. Olive green linework and hatching brings internal structure and some parts of the silhouettes of both bangles into more focus.

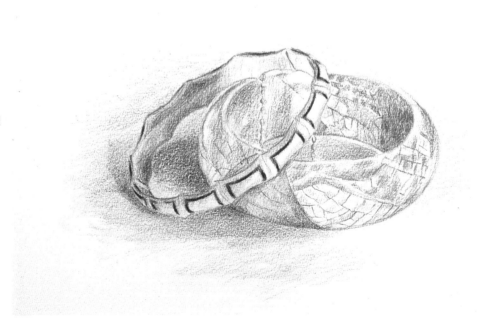

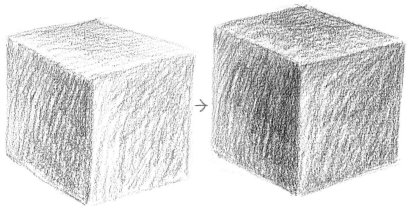

COLORED GRAYS

Colors can be dulled by using colors that are opposite to each other. Here a red-orange and a blue-green mute each other's intensities as they are shaded or hatched together. The red, being slightly more powerful, predominates and ensures that a neutral gray is not reached. However, the result is certainly dull, while full of color — a true colored gray.

WHEN TO USE BLACK

It is enticing to use black early on in order to create the values for overlaid color. While this is effective, it does lead to a deadening of the color.

For more vibrant colors, use the color itself or color mixes. Build up as much value contrast as possible and only then bring in the black for final linework and shading. In this example, the minimal use of black makes the color appear as a dark green, rather than a neutral.

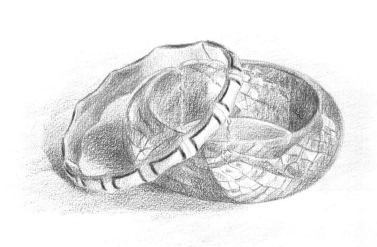

Step 6

Warm colors laid gently over the cool bring a touch of contrast. Where they are laid over the white paper they remain warm, providing highlights. Where they overlap cool colors, a colored gray results. You can see them as the gentle pink at the top edge of the blue bangle and as the yellow at the top of the large one. By this stage you can see how the paper grain is being revealed. This is an inevitable quality and you must incorporate it into the result. An unpleasant texture will probably mean you need to use a different paper. More olive green to the bangle and blue over the warm shadow begins to provide the darker accents against which the lighter areas can shine.

Step 7

The black pencil, which has been intentionally avoided to this point, is now brought into play. Black is most useful, especially when you only have a limited palette, for it now provides the final clarity to the drawing. Having already achieved soft colored darks, you will be far less likely to overuse it, which could lead to a deadening of the color balance.

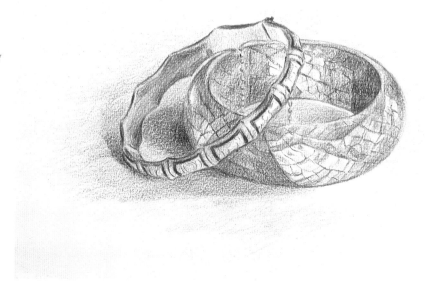

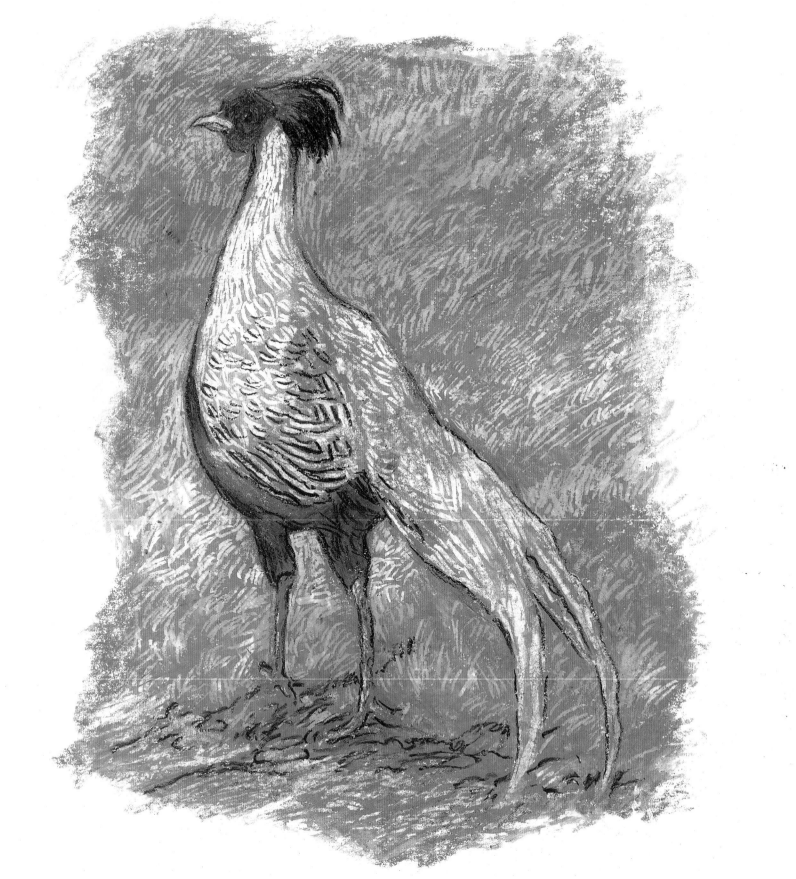

OIL PASTELS

Introduction

I have to confess that many years ago, on trying out a box of oil pastels for the first time, they didn't appeal to me. The problem being that I simply didn't understand the media: a common frustration shared by everyone tackling something for the first time. This inevitably leads to poor results and a dampening of enthusiasm.

Oil pastels have several idiosyncrasies that could hamper your immediate enjoyment of the medium, and it is worth getting to grips with these straight away. First, don't work on too small scale. Second, don't let the relatively limited palette of colors restrict you, for they can be mixed on the surface. Third, get to understand the nature of this medium by using it frequently, and learn how it can be best exploited.

Don't do what I did all those years ago, which was to throw the set in the back of the cupboard and forget all about them. I tell this story simply because I know this reaction is not unique to myself; it is something that I hear time and again from others who become disillusioned purely through lack of understanding.

Happily, I returned to re-examine this medium and assessing its merits against other media. Furthermore, manufacturers were extending the range of colors and varieties, which encouraged my research into it.

As their name suggests, oil pastels feel oily or waxy when drawn across the surface. Being soft, they blunt swiftly, but worked on a medium to large scale, the line created can be suitably fine and certainly descriptive. As this is built up into hatching and cross-hatching, mixing on the surface is carried out quite successfully.

Eventually, as the surface becomes covered, the pastels begin to blend in quite an individual manner. The oily marks blur into one another, and this effect can be accelerated by pressured shading being applied over previously laid areas. Undoubtedly, if this effect is overworked, it may become heavy and dirty, just as with any other media that is overplayed.

One of the most interesting and different features of these pastels is the opportunity to scratch through the thick oily layers. Most useful for carrying out alterations or as a technique in its own right to expose previously laid layers of color or texture. The two projects in this section exploit this property.

This technique of scraping through the pastel layers gives an image that is as detailed and sharply focussed as is possible in any other medium, while possessing qualities unique to the oil pastels.

If only I had known all those years ago what I subsequently discovered, for I would have had the joy of using oil pastels all the sooner.

Materials

1. Students' Quality oil pastels (inexpensive but limited in range) usually available in sets.
2. Artists' Quality (much larger and subtle palette of colors).
3. Square - shaped pastels (shape does not affect the quality)choice of shape based on personal preference.
4. Thinners (for dissolving pastel on surface). Either Artists' Quality Distilled Turpentine, White Spirit, or Odourless Thinner.
5. Brush for spreading thinner and dissolved oil pastel pigment. Soft - hair brushes are gentle (bristle brushes more aggressive).
6. Erasing Knife (with curved blade for scratching, scribing, and scraping through oil pastel layers).
7. Scalpel or Penknife (alternatives to erasing knife).
8. Cartridge paper for direct work.
9. Oil paper for dissolved pastel work.
10. Oil boards for dissolving or mixing media with oil paint.

NOTE: There is a proprietary oil pastel varnish, but it is seldom available off the shelf. I have found a suitable alternative: a layer of undiluted acrylic medium (either gloss or matt), depending on the finish you require. There is no need to varnish oil pastel work unless it is placed somewhere where it may become vulnerable to physical damage. The simplest answer is to have the work framed behind glass as soon as possible.

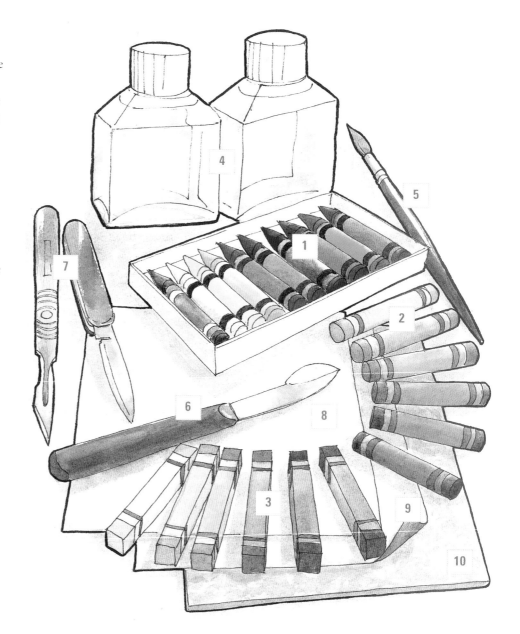

Oil pastels are too soft to sharpen in a pencil sharpener. In the first place, they will not sharpen well, and even if this were possible, they become blunt moments after they are put to use. Instead, use the natural shaping of the pastel for drawing and detail work. Start by using the edge of the pastel end. As this blunts, rotate the pastel in your finger. Eventually, a point develops in the middle. Use this until it wears down to the shape you started with.

During storage, oil pastels often develop a white bloom on their surface. While this does not affect their application, it can be confusing when choosing the color you wish to use. To reveal the original color, simply scrape the end with your fingernail or a craft knife.

For more general shading, hold the pastel flatter to the surface, in the manner shown, and an even longer point will develop for the beginning of your next piece.

The pastels come with a paper jacket, designed to prevent soiling your fingers and other pastels during use. Remove only a small section at a time to retain this advantage, unless you are breaking off a small length to use edge-on. In this case, keep this pastel piece for that purpose only so that the rest of the pastel can be used with its jacket intact.

Hints & Tips

Technique: Grattage

LAYERING THE OIL PASTEL

Bright colors are intermixed on the surface with directional linework and hatching Use the point of the oil pastel stick and build gently. Only colors laid directly on paper can grip and become permanent. Overlaid pastel is unsupported and easily moved. Once the surface is covered, the color no longer adheres, but blends with the color already present.

The second and third layers involve a single color, applied gently, which tends to catch the most prominent or heavily laid areas of pastel. The third application is heavier, forcing colors into the gaps that remain, making coverage more solid. Don't over worry that some of the first layer pigment still shows, as long as it has a covering of the single overall layer.

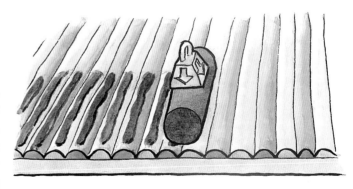

Materials

Good Quality Cartridge Paper

Tracing Paper

2B Pencil

Kneadable Putty Eraser

Oil Pastels

Erasing Knife (or similar)

Bristle Brush

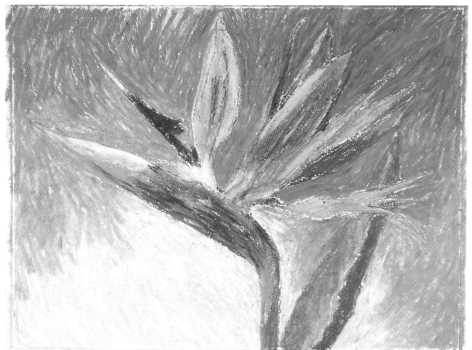

Step 1

As two similar images are to be created, for this exercise and the second one on page 35, you can either draw out in pencil and then take a tracing or create your shape on tracing paper and transfer the result to two different sheets of smooth cartridge paper. Lightly establish the image in pencil, and then apply the first layer of pastel. If the technique is to work, this first layer must entirely cover the paper surface. These highlight bright colors, adhere to the fibers of the paper, and are built up until they create a barrier layer for the next stage. Any gaps will mean that the overlay color will reach through and itself adhere, making it impossible to remove.

Step 2

Using one color only, cover the entire colored surface with a second layer of oil pastel. This will take at least two passes across the surface. The first time you should move swiftly and lightly, establishing the color with as little disturbance as possible to the bright colors beneath. The second time over you can apply more pressure, ensuring that you fill any gaps left after your first pass. The result looks frightening and frightful, but don't despair; it is only a step along the way.

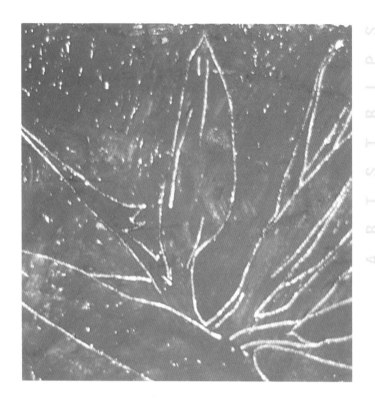

A R T S T R I P S

Draw out image with pencil on tracing paper. Erase and rework until proportions are correct.

Turn trace over and redraw essential linework strongly on reverse.

Turn back and place over cartridge paper. Rub down with spoon. Repeat for as many number of images as you intend to create.

Store trace safely between sheets of paper for later use.

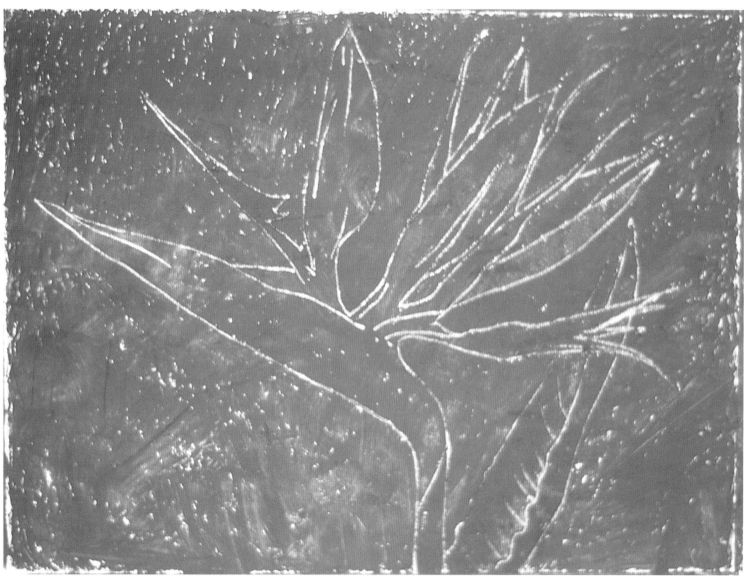

Step 3

Reuse the original trace to outline the main shapes of the flower head (see Artstrip Page 36). Although you can almost see the flower beneath the overall pastel layer, there isn't enough information to achieve the fine detail possible. Using the trace again is therefore an essential element in being able to see through the morass of overlaid pastel. Accuracy at this stage is important, so do ensure that the trace is laid correctly over the rectangle already drawn. One final point to consider at this stage. While the line laid bare by the trace is used purely as a guide in this instance, could this line be used as a technique in it's own right? Perhaps this is worth some further investigation!

CURVED BLADES

The blade of the erasing knife has both a point for fine linework and a curved edge for bolder strokes. An increase in pressure ensures a deeper and wider incision through the top layer of pastel. With this deeper push, some of the underlayer is also removed; thus, it becomes a little thinner and lighter. A simple penknife can also prove an excellent cutting tool. The curve of its blade is not so marked and will therefore not produce such a wide stroke. Nevertheless, the line it produces is decisive and variable.

POINTED BLADES

The point of a blade creates a fine line as it cuts through the top layer of oil pastel. Even the seemingly crude craft knife can provide quite delicate hatching and cross-hatching. As you move on to the scalpel, the possibilities are wider. By gradually changing the angle at which the blade meets the surface, different cuts can be achieved. Eventually, an almost flat blade is presented, producing a characteristic scuffed stroke.

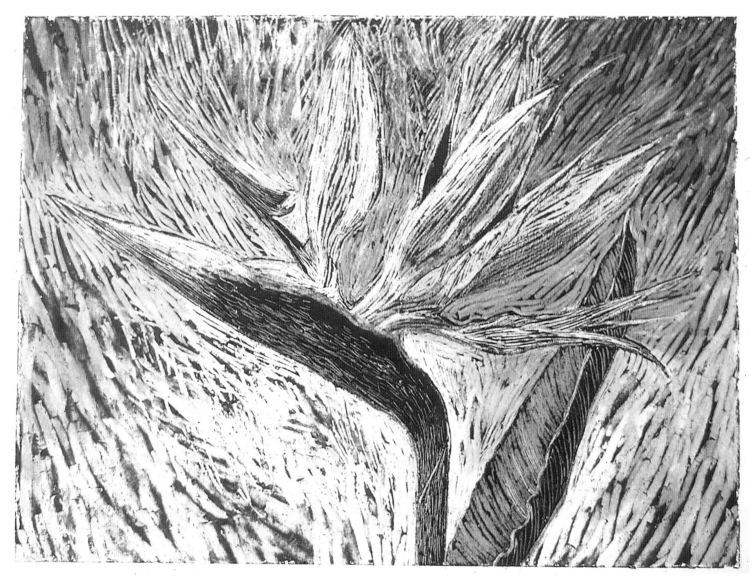

Step 4

This is the stage where all the careful preparation and patience you have shown pays off. Generally, the direction of the hatching and linework follows the form. In the background it provides a dynamic backdrop that echoes the growing patterns of the plant, in an explosion of color. Note how the white under pastel, which may have seemed almost superfluous at Step 1, now begins to make sense as a color. If this had not been applied before the brown, the latter would not have been able to be removed at this stage. All of these strokes were created with an erasing knife, so comparing these to the other linework achievable with other types of blades gives you plenty of scope for future experimentation.

Technique: Grattage

CHOOSING THE CORRECT CONTRAST COLOR.

It may seem a little odd to create two images so similar. In fact, the first stage is more or less identical in both cases. The purpose of these two exercises is to make a strong point about color layering, by making the images easy to compare.

CONTRAST OF VALUE

The first example, overlaying a dark brown would probably be the most obvious choice, as a dark color covers more easily. The colored diagram shows the flowers that are all light in value, as in the first layer of pastel in the first exercise. The orange and purple have had white intermixed to bring them closer to the value of the yellow. This white dulls them slightly against the purer yellow. However, when surrounded by the dark brown, the strongest contrasts are between the flowers and the brown background. Thus a contrast of value is established, which is more visible when the diagram is changed to gray tones. Now when you look at the first exercise it is obvious that its drama is directly related to the contrast of value.

CONTRAST OF INTENSITY

The second exercise is overlaid with a neutral gray. The flowers are now much closer in value to the gray. As the color is leached away to gray tones, you can see how close these values are. The top flower is just a little lighter, the bottom right a little darker, but the middle left more or less disappears, showing that its value exactly matches the gray background. Note how in the color diagram even those colors dulled with white glow against the gray, because of their intensity. In the second exercise, the result of cutting through the gray overlay to the bright colors beneath causes a contrast of intensity. All the colors seem more vibrant.

In the first project we have contrasts that seem to create light; in the second project, they create color. Now you can make an informed choice, knowing where to look.

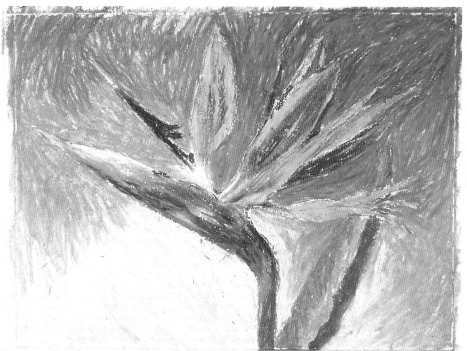

Step 1

This is an almost exact copy of Step 1 on Page 29. Parallel strokes of pastel build up and are mixed, wiped, or blurred together as the colors start to be overlaid. Background colors are drawn right up to the flower edges, almost overlapping to ensure continuation of coverage. Graded blues to white are used here to echo the contours of the flower itself.

Step 2

Now the oil pastel is used edge-on for fast coverage. Two passes with a mid neutral gray entirely cover the first bright layer. The shape or silhouette of the flowers can be seen more clearly this time around. Nevertheless, every bit of the surface has been covered and will react to being cut with the blade. Even at this stage, which by now you recognize as visually the worst, the colors look exciting, being all of a high key (no darks).

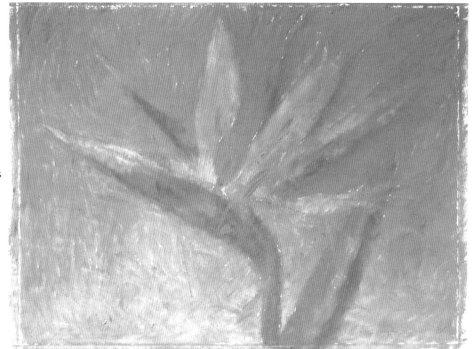

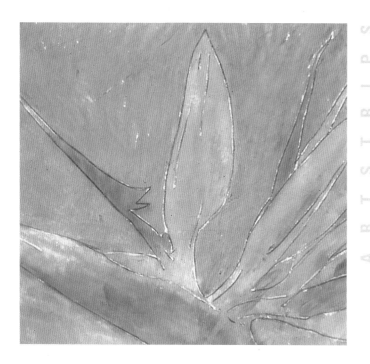

Relay earlier trace accurately over rectangle of solidly laid pastel.

Use ballpoint pen to trace around silhouettes of main elements.

Heavy ballpoint pen line lifts a line of pastel beneath, which sticks to underside of trace. Occasionally lift trace to check progress.

For greater accuracy, employ grid marks at corner of trace and pastel, so as to position one above the other.

Step 3

Reusing the trace to redraw the silhouette as before has not only lifted pastel but has also transferred some of the graphite from the trace. This helps to define the edge, but could be avoided if you wish by creating a new trace with the "positive" drawing on one side only.

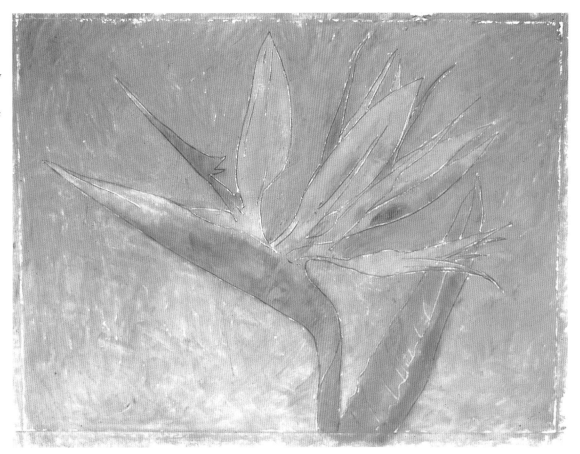

BACKING SUPPORT

Working with pastel on thin cartridge paper may pick up the pattern of underlying surfaces, such as the grain of the wood of your drawing board. Should this occur, you could support the paper with a sheet of smooth cardstock or a layer of newspapers. However, you might consider whether or not such rubbings could be incorporated into your technique?

MASKING TAPE

Oil pastel paintings tend to have messy edges. Before you start, you may prefer to mask the edges with masking tape, but beware, as the pressure used to apply your pastels may adhere the tape strongly to the paper and cause tearing when removed. This could be reduced by sticking the tape length to a smooth article of your clothing, such as a shirt or blouse, but

avoid picking up long hairs. This will render it less tacky and thus easier to remove from the paper surface.

[A] More gray left at edges of composition, creating vignette effect with more light at the center.

[B] Long directional strokes give structure and finish to the petals.

[C] Short, staccato scratches, using knifepoint create texture and color.

[D] Earlier applied white pastel now acts as strong color against the gray.

[E] Mosaic effect of strokes carries the eye around the composition. Curved blade used to scoop away broad bold strokes.

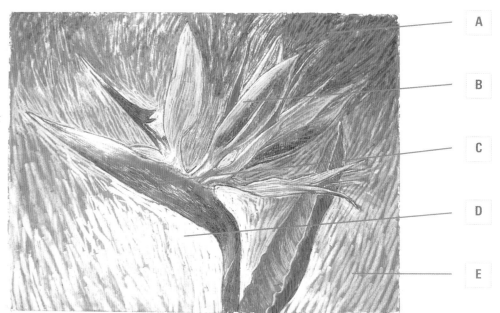

A

B

C

D

E

FINAL TIPS

Clean knife blade regularly with a tissue to prevent build up of oil pastel particles, which could adhere or smear across the work in progress. Use a dry clean bristle brush, at a very low angle, to gently brush away any cut particles that are clinging to the surface.

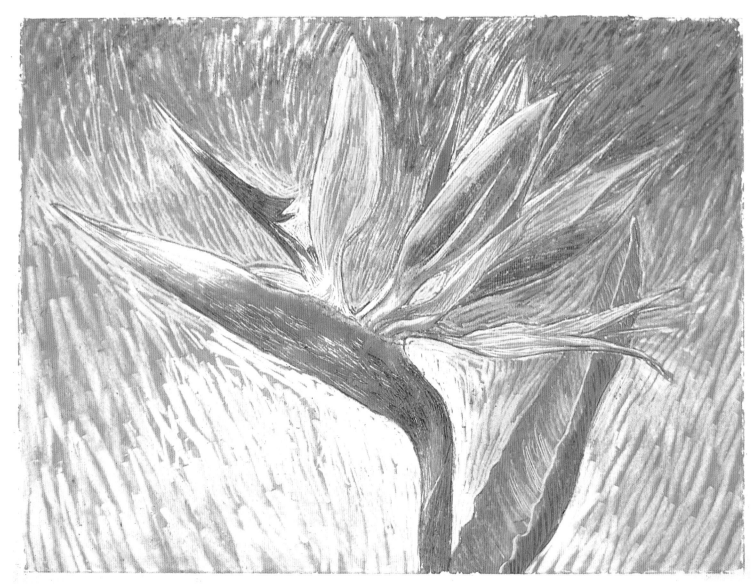

Step 4

A colorful climax to this impression of an exotic flower head. The result is certainly not photographically realistic, being more akin to a design. This is caused by the surface structure, which holds our eye like the pieces of a mosaic design. However, strong movement and colors enhance this simple subject so that one is as involved with the quality of the surface as in whether it is an accurate portrayal of the flower. It is interesting that while the work features focus and detail, it is the strokes and color that capture our attention and imagination.

Introduction

There probably isn't a more misunderstood medium than pastel. Its very name conjures up pastel shades and wishy-washy colors that are inoffensively gentle.

What constitutes a pastel? There are so many crayons, chalks, and pastel pencils that it can all seem very confusing. Furthermore, artists — myself included — use the term "pastel painting," yet pastel is a dry medium.

I, for one, was just as perplexed when first starting to paint and would not have even contemplated using pastels, for there was quite enough to stimulate my imagination with paints.

All that changed on a visit to an English country house where I came upon a portrait, the colors of which were so stunning that I immediately assumed it was produced in oils. On referring to the guidebook, however, I discovered the medium was in fact pastel. It didn't seem possible; surely there was a mistake! The color and the handling of the strokes could only be the result of brush strokes. If this was pastel,

then I had to know how they functioned. I was hooked.

It was only later that I began to understand how close pastels are to oil painting.

Although dry, pastels can be built up in layers, and strangely, as the layers grow in depth, the surface beings to feel fluid, not unlike working with paint.

Purchasing pastels can seem daunting, especially as they may seem expensive and there is a vast array from which to choose. Undoubtedly, buying pastels without being knowledgeable can lead to expensive mistakes. Far better to start with a cheaper boxed set of pastels. These are widely available, and at least allow you to experiment with the medium before you have to make any hard and fast decisions.

Dry pastels are those that are not oil or waxy. Nearly all are described as "soft" pastels, although it is only the top range that is truly soft and contains the most pigment. Working with the more economical varieties will not allow you to build as many layers

or create the same impact with color, but they will allow you to develop your skills. When you subsequently feel the need to move on to the more expensive ranges, you will be equipped with the knowledge with which to make considered choices.

The following composition was rendered entirely from a boxed set of cheaper pastels, and as you work through it I am certain you will agree that they do the job well.

Within a relatively short time of working with pastels you will begin to identify their advantages. Being dry, they need no mediums, palettes, brushes, or expensive surfaces on which to work.

You may well want to kit up with accessories with which to experiment further. To begin with, however, all you need do is pick up a pastel, make a mark, and your venture into the world of pastel painting will have started.

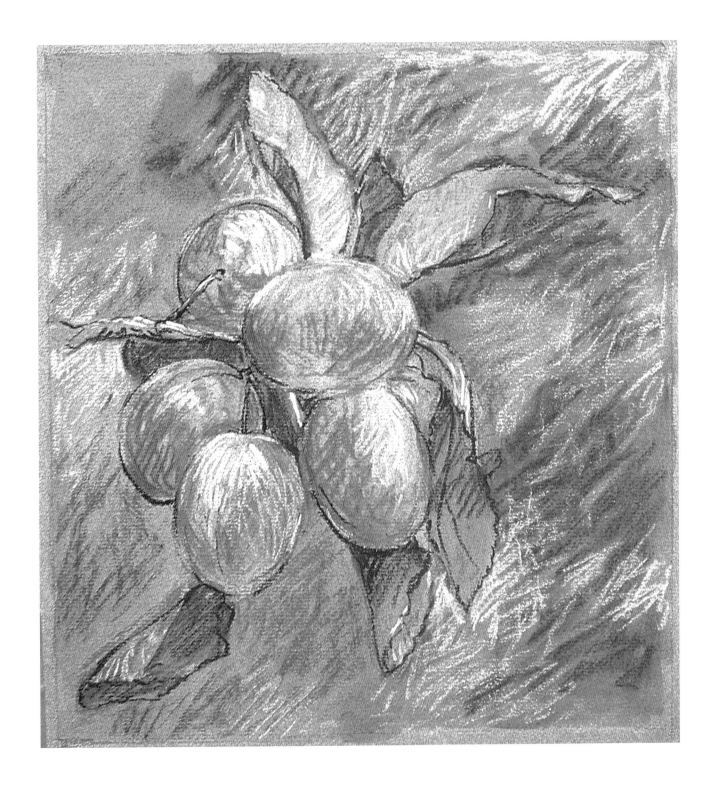

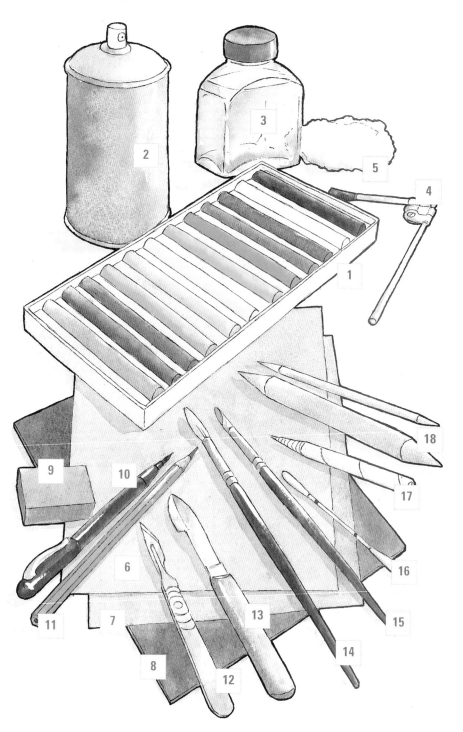

Materials

1. Boxed Set Soft (sketching) Pastels
2. Spray Fixative
3. Liquid Fixative
4. Spray Diffuser for Liquid Fixative
5. Cotton Wool Balls
6. Pastel Paper (various colors)
7. Fine Sandpaper
8. Pastel Board (various colors)
9. Kneadable Putty Eraser
10. Brush Pen
11. 2B Pencil
12. Scalpel (or Craft Knife)
13. Erasing Knife
14. Bristle Brush
15. Pastel Blender
16. Cotton Bud
17. Rolled Paper Blender
18. Compressed Paper Wipers (various sizes)

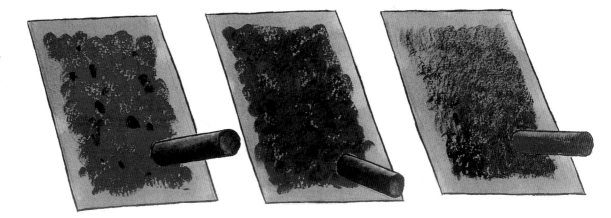

USING BLACK PASTEL

Black is a useful color to the pastel artist, especially when faced with a limited range of colors — as in a boxed pastel set. In the past it has often been termed a "royal" color, since used in small areas as accents it can excite the color around it (left diagram). Degas was particularly fond of this aspect of black, and a close study of several of his ballet pastel paintings will reveal his judicious use of this pigment. However, overuse of black, especially when worked over the top of a color to darken it, will have the tendency to dull and dirty the surface (middle diagram). Far better to lay the black as a "ground" on top of which the colored pigment can be applied (right diagram). By grading the black, a tonal range is created, which will help to create volume in the overlaid color layer.

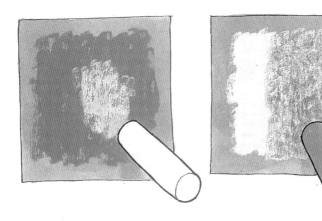

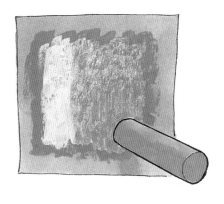

USING WHITE PASTEL

White is one of the cheaper pigments, being easily obtained. The lower the price of a pastel, the more white it is likely to contain. Hence a low-priced set of pastels is likely to consist of very gentle colors. Nevertheless, whatever their density, colors can still be lightened, and it is natural to add white on top of the color you wish to lighten (left diagram). However, adding more white also dulls the color, for it reduces the intensity. To combat this, try laying the white first, with the color applied on top (middle diagram). If you have already put white on top of a color, then add a second layer of color into the white (right diagram). This works for both large areas and small touches of highlight.

Step 1
Hints & Tips

WORKING SURFACE

Pastel papers are relatively thin, and as the pastel is rubbed across the surface, it will pick up any textures beneath, such as the grain of the drawing board. While a smooth drawing board can be used, it does however give a very hard surface on which to work. It is better to cushion the paper, by laying a few sheets of paper beneath the surface on which you are going to work. Anything will do, as long as it is smooth. Fix everything with masking tape.

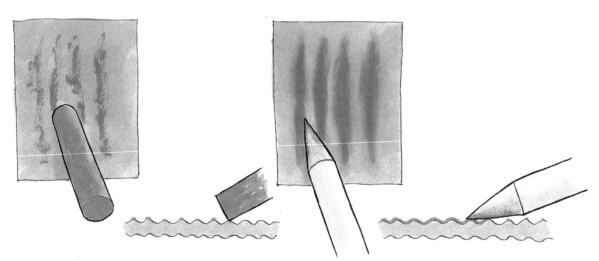

Materials

Tinted Pastel Paper

2B Pencil

Boxed Set Soft Sketching Pastels

Compressed Paper Wiper

Brush Pen

Kneadable Putty Eraser

Smooth Drawing Board or Drawing Surface

BLENDING STROKES

Even sketching pastels are dense in pigment, and the initial strokes are misleading, for they do not fully indicate the amount of color on the surface. If too much pastel is applied at this stage, it will either have a tendency to fall off or make it difficult for further pastel to be applied, as it will have swamped the tooth of the paper. It is advisable, therefore, to use a blender or paper wiper very early on so that the pastel can be spread, the surface consolidated, and the weight of pigment on the surface made visible.

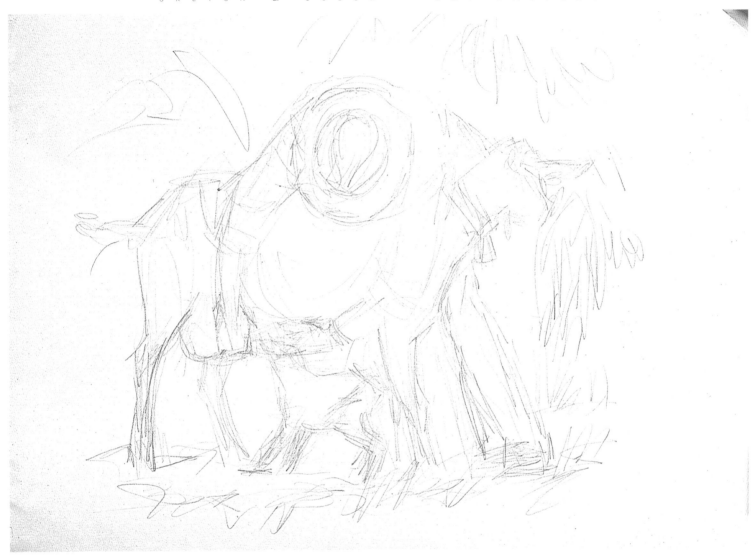

Step 1

While this pastel sketch on tinted pastel paper is relatively simple, careful observation of the subject is required. The man leaning over the goat does not have the proportions we would expect. His torso is foreshortened as he leans toward us so that it is hidden behind his hat. The only way to get such a drawing correct is to forget that he is a man. Just look at geometric shapes. His round hat, the oval shape made by his arms, and the long rectangle of his leg that is angled toward his hat. It will also help to concentrate on the negative spaces between the goats legs and the spaces between them and the little kid. Start the sketch off with a 2B pencil, keeping the drawing scribbly and loose until it evolves. By working in this way, you won't worry about mistakes and will keep scribbling and correcting by dabbing off with the kneadable putty eraser until you are satisfied.

Step 2

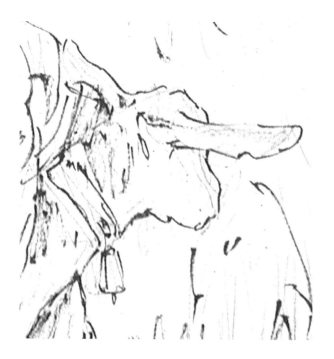

From a mass of scribbling line...

...begin to tighten shapes.

NOTE: even strong pencil lines are only guidelines. Make necessary changes as you add the ink line.

Apply slowly and use brush point for definitive linework. Speed up and use edge-on for soft scuffing.

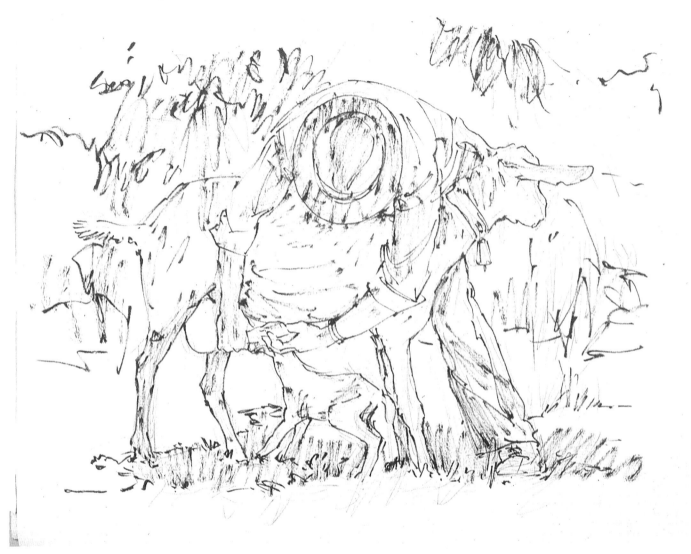

Step 2

Switch to brush pen to better define silhouette. Don't worry that mistakes cannot be erased — pastel is opaque and will cover wherever necessary. With this confidence you can loosen up, which will be reflected in the relaxed freedom of the line.

Concentrate on the silhouette first; then begin blocking in with rhythmic strokes, holding the pen flatter to the surface to introduce the brush head edge-on. These strokes pick up the rhythms and movement, which will be echoed later in the pastel.

Stop sooner, rather than later, before you overwork. The line is a guide only and does not need to be dominant. So move on to the pastel as soon as you have enough linework to give you confidence in the application of the bolder pastel strokes.

Step 3

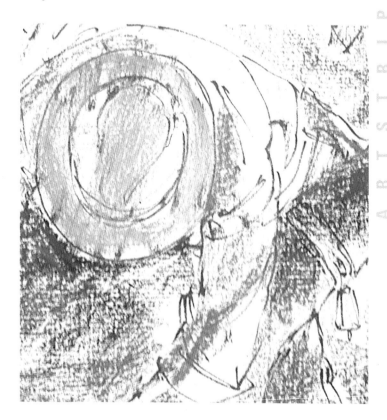

ARTSTRIPS

Round or square pastels — peel off end of sleeve — score exposed pastel stick with nail or blade.

Small piece now breaks off easily.

Use this piece to block on color. Overwhelm shading, but not silhouette line.

Leave paper color as highlight. Avoid using white for as long as possible.

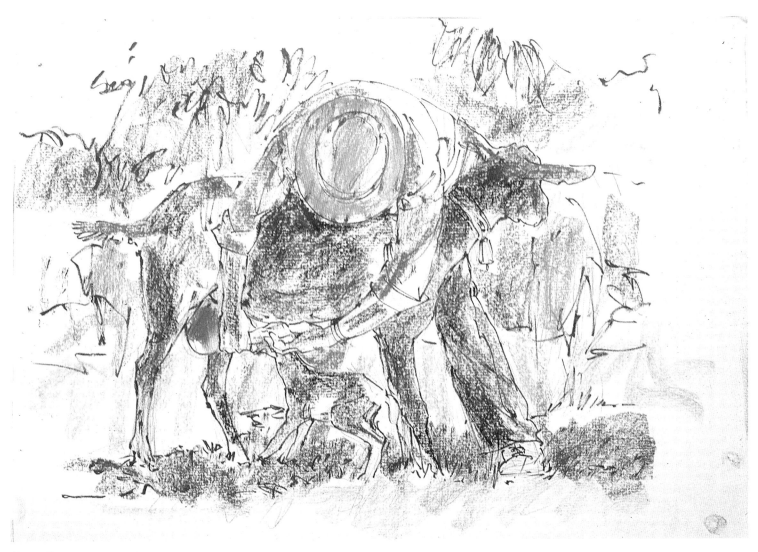

Step 3

These first layers of color are used to form the dark underpainting of your pastel painting. Use black under many of the colors to provide the density required. Even if the resultant mix, once blended, becomes a little dull, it will still provide a contrast for the brighter colors to be laid on top. Be careful not to overdo the coverage. The texture of the paper breaks up the strokes, giving the impression that the colors are underplayed. These colors will become much more powerful once they begin to spread across the surface. Over application may lead to the drawing becoming completely obliterated once the blending begins. With a limited color range, you may not have the exact colors to replicate the subject. As long as the value of the color is mimicked, the subject will have form, depth, and light. Using limited colors ensures the picture will balance well in terms of color, so push the materials you have to their extremes instead of rushing off to buy others.

Step 4

[A] Black rises through the colors powerfully, but is not dead, as it is influenced by the colors that overlay it.

[B] Strokes are wiped or blended in the direction in which they were laid. Color intensifies, edges soften, but rhythms remain.

[C] Paper allowed to show through acts as another color.

[D] Strong silhouette lines still visible.

[E] Blocking-in lines are partially or totally overwhelmed by pastel underpainting.

[F] Negative shapes between legs help to ensure proportion and positive shapes are correct.

[G] Pastel colors are kept simple on this layer.

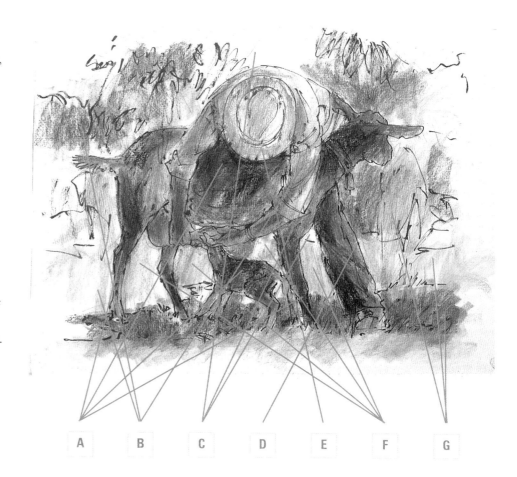

A B C D E F G

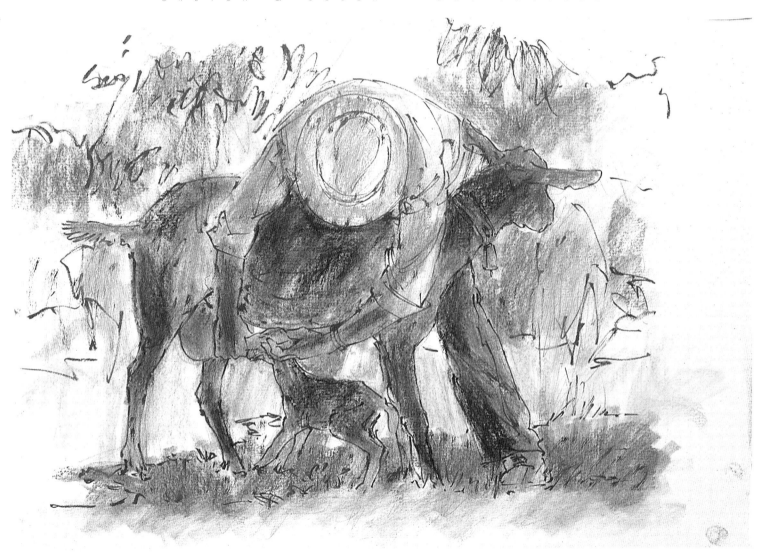

Step 4

SURFACE MIXING

The slightly harder pastel reacts well to the compressed paper wiper. Blend all of one color family (i.e. greens) before wiping blender on a tissue and moving on to blend another (i.e. browns). While this layer needs to be dark, too much transferral of color and the surface will look dirty and the identity of individual areas will be subsequently lost. You really can be quite aggressive with the pressure used to force the pigment into the surface of the pastel paper. This will ensure that you get right down into the textures and that the pigment is impacted into the fibers of the paper, making future layers easier to overlay. The overall effect of this blending stage is the solidification of the compositional elements. Wherever the paper's color is eliminated, the shapes become solid and we have a mass to which highlights can be fixed.

Step 5

ARTSTRIPS

End of pastel sticks now provide finer strokes.

NEGATIVE SPACES: Begin light strokes tight against the legs, moving into the negative space.

Repeat process from edge of other leg to give impression that the texture passes behind the limbs.

Directional strokes create volume, form, and reassert the rhythms throughout the composition.

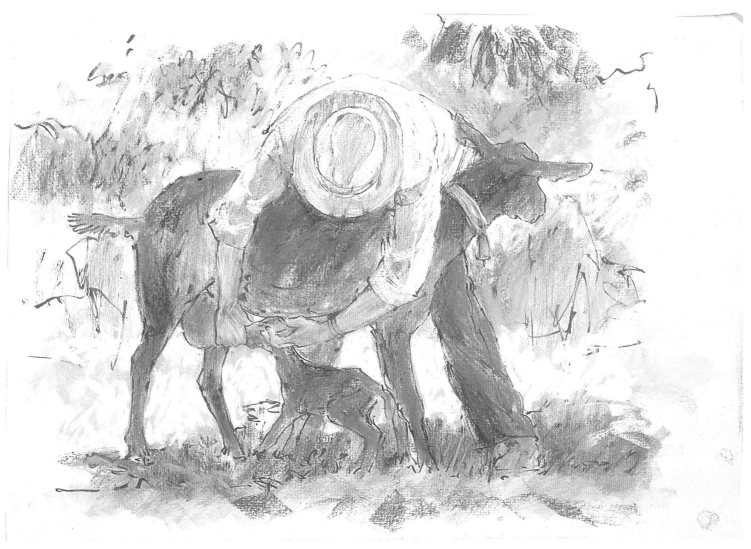

Step 5

Now begins the exciting journey back into light. Much of the black remaining in the shadow is covered with blue. This is the cool reflected light that gives light to shadow areas. The silhouette line is progressively diminishing in strength, against the opaque color, but still plays its part. Color is excited as cool colors are laid over warm (e.g. coat of goat) and warm over cool (e.g. grass shadow). Elsewhere, the values are lightened. Always ensure that dark undercolors are not covered but allowed to work as accents against the lighter, brighter layer. Once again, the accent is on keeping the approach loose, to suggest movement and light within the subject. Even at this stage, the colors are a scribbly mix.

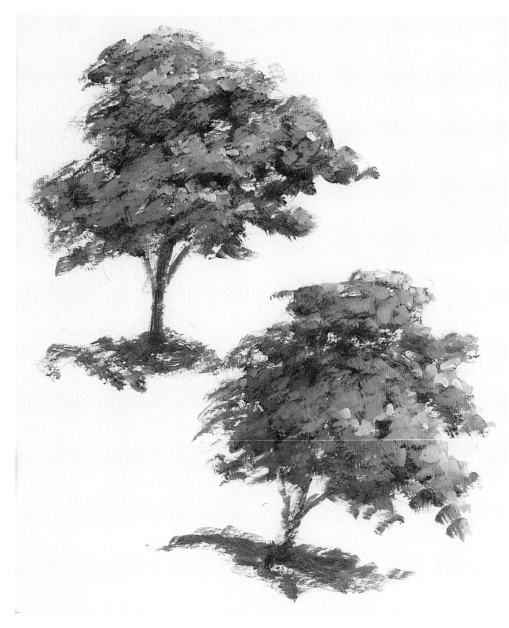

Step 6
Hints & Tips

IMPORTANCE OF YELLOW

Here are two trees, both of which have had their foliage built up in opaque layers of pastel color. Both were begun as flat, soft silhouettes in the dark green that can be seen at the base of each tree. The first tree (top) was given some reflected highlights on the left hand side. This color consists of blue and white, added to the existing color. On the light side of the tree, white alone was progressively added to the base color. While the foliage has form, the color is, however, relatively dead. You could imagine this is how the tree might appear on a dull, overcast day.

On the other hand, for the second tree, the reflected highlights are slightly biased toward purple. While this has been exaggerated somewhat for the purpose of this diagram, you can see how it enlivens the dark green around it and is especially effective against the yellow that is its complementary. The right hand side of the tree foliage has been both lightened with white and brightened with a change of hue from added yellow. This immediately suggests the effect of sunlight.

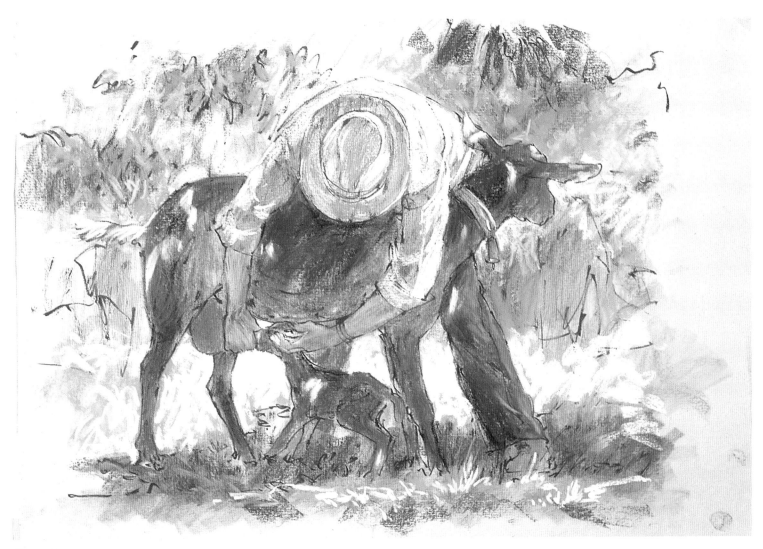

Step 6

The most important aspect of this stage is the introduction of yellow. Without yellow there can be no sunlight, regardless of how much white is applied. The shadows receive some purple = blue reflected light. This is not only warm over the cool blue, but is the complementary color to yellow. The Impressionist painters always used this trick to relieve the shadows of their sun-filled paintings, and with its addition the color begins to shine. Spots of sunlight are applied across the figure and animals as it filters down through the leaves. There are splashes of yellow ochre with added white. While they are erratically placed, the strokes on application follow the lie of the form onto which they fall. This has the effect of breaking the solidity of the mass, while still confirming its presence.

Bring yellow into all your colors to imbue warmth and sunlight into your work. Without it, your work will always be drab and cold, no matter how well you can render the subject.

Introduction

The combination of pen and brush has been exploited through generations of artists. From Leonardo da Vinci to Pablo Picasso, the materials may have been similar, but the results were as unique as the artists that created them.

Today, we probably have a greater range of different pens than at any other time in history. It almost seems that on every shopping trip for art materials there is something new to tempt us, so why not take the opportunity to try out some of the wonderful array?

You could start off at the cheapest end of the scale, with felt-tip pens. It is important to watch out for whether or not they are waterproof and/or lightfast. It is better to go for lightfast pens so that your efforts do not fade into oblivion within weeks.

From this start, you can move on to dip and drawing pens. Dip pens may well be familiar to you from school days. Drawing pens tend to come with an integral ink cartridge, to cut down on the need for constant refilling. Then there are fiber-tip pens and mechanical pens, which deliver a very fine line, available in different widths - from 0.1mm to 1.2mm.

Finally, the delight to be had from exploiting a range of unique characteristics offered by the traditional reed and bamboo pens.

The wide variety of natural and man-made materials employed in such a range of tools consequently yields different types of marks. Why not, therefore, exploit these differences in the approach chosen for a particular subject?

The strength of the brush lies in the fact that its shape molds to the surface, facilitating coverage, strokes, and texture. The shape of the brush and the flexibility of its head alter the manner in which it performs.

When combined with the pen, the role of the brush is given much more freedom. Since the line is very defined and suitable for rendering detail and focus, the brush can deliver flowing color and texture, which may, or may not, be restricted by the line beneath. This is a wonderful way to enter the world of color and paint, as the demand on the paint layer is so light — given that so much is already stated by the line. This sense of freedom with the materials is something of which no artist tires and provides years of satisfaction and exploration.

Just as there is a wealth of tools available to create line and color, so there is a great choice of surfaces on which to work. Absorbency and strength are the governing elements in your choice.

Pens have hard points, which are drawn across the surface. The interaction of these points with the texture and absorbency of the fibers will alter the resultant mark.

There are no rights and wrongs here. Even if the pen scratches and pulls at the fibers, the line will be unique. It is simply a matter of reacting positively to the marks and exploiting the result.

The color can be dramatically different on different surface textures and absorbency. In pure watercolor you might worry if the surface was too absorbent, for this may create unwanted texture. Here, however, since the color is applied swiftly, loosely, and in the expectancy of the unexpected, you are much more likely to be pleasantly surprised by the results.

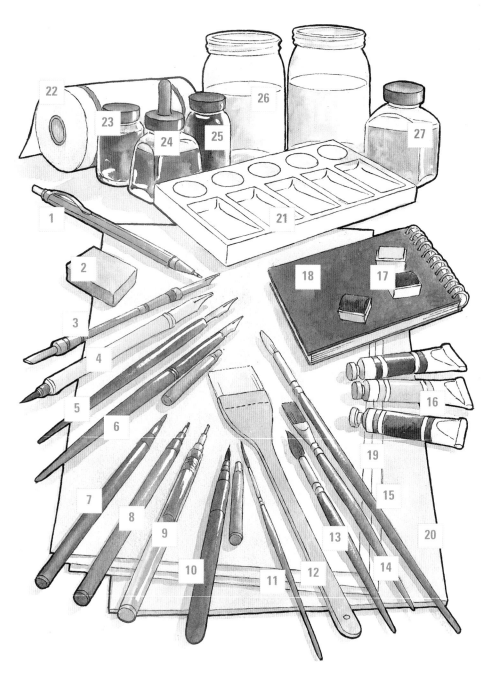

Materials

1. Pencil
2. Kneadable Putty Eraser
3. Reed Pen
4. Bamboo Pen
5. Dip Pen
6. Drawing Pen with Cartridge
7. Felt Tip Pen
8. Fiber Tip Pen
9. Mechanical Pen
10. Brush Pen with Cartridge
11. Rigger Brush
12. Hake Brush
13. Round Nylon/Sable No. 10 Brush
14. Nylon Flat Wash Brush
15. Bristle Brush
16. Tube Watercolor Paints
17. Pan Watercolor Paints
18. Spiral Bound Sketch Book
19. Rough, NOT and Hot Pressed Watercolor Paper (well-sized)
20. Line & Wash Board
21. Ceramic Palette
22. Absorbent Paper Towel
23. Waterproof Drawing Inks
24. Waterproof Indian Ink
25. Non-Waterproof Inks
26. Water Pots
27. Masking Fluid

1.USING THE PAPER: WATERCOLOR LIFT-OFF

Having dried, watercolor can be re wet and dabbed off with an absorbent tissue to reintroduce light areas and highlights. The amount and speed of lift depends more on the surface than on the paint. A poorly sized surface will have absorbed color into its fibers and will retain color. Well-sized papers can lift off to almost white.

2.USING THE PAPER: INK MASK

Since ink is permanent when dry, the colors must be prevented from reaching the surface, if the white of the paper is to show. Using masking fluid is the answer. Here the mark is scumbled inside the pencil outline, picking up the paper's texture. Once the applied ink is dry, the mask is removed with a kneadable putty eraser. The resultant texture could be given a second, lighter wash, avoiding only a tiny highlight area. This will soften the texture.

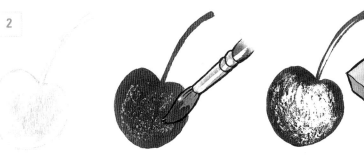

3.DEALING WITH HARD EDGES: WATERCOLOR

In this series of diagrams, a hard edge is left once the masked area has been removed. Use a wet, flat nylon brush to swiftly remove the edge, softening the masked area, so that it becomes part of the curved surface of the fruit. Being a little more resilient than natural fibers, the nylon brush is more adept at doing this. Dab away any color with an absorbent paper towel.

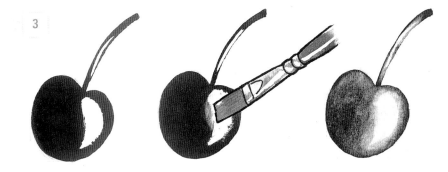

4.DEALING WITH HARD EDGES: INK

Ink cannot be dissolved once dry and therefore has to be moved using more aggressive means. Take a knife or scalpel and gently scrape away the surface. Note how the curved blade, used delicately, tends to pick out the higher textures of the paper surface. This surface is now damaged, and as a result, any future washes of either ink or watercolor will have direct access to the open paper fibers, causing deep staining. This will be difficult to remove without further scratching.

Hints & Tips

INK SHADING UNDER
WATERCOLOR

The diagrams show two
distinct methods of laying
ink tones beneath simple
watercolor washes. Since
the ink is waterproof,
there is no danger of the
black ink, used in this
instance, destroying the
clarity of the applied color
washes.

In the first example the
volume is represented in
line shading. The hatched
and cross-hatched strokes
are also curved to further
suggest the roundness of
the form. When color is
washed over, there is
plenty of white paper
between the marks to
display the color
effectively.

In the second example, diluted washes of
waterproof Indian ink create the light and dark
variation across the skin of the fruit. The same
color and density of color wash is applied again,
with quite different result. Now the skin is less
textured, and the colors are muted by the gray
tones beneath.

Materials
Well-sized Watercolor Paper: Hot Pressed or NOT
2B Pencil
Waterproof Drawing Inks: Black, Red, Yellow
Reed Pen
Ceramic Welled Palette
Box of Pan Watercolors
Round Watercolor Brushes: Nos 8, 10, 12
Masking Fluid
Kneadable Putty Eraser

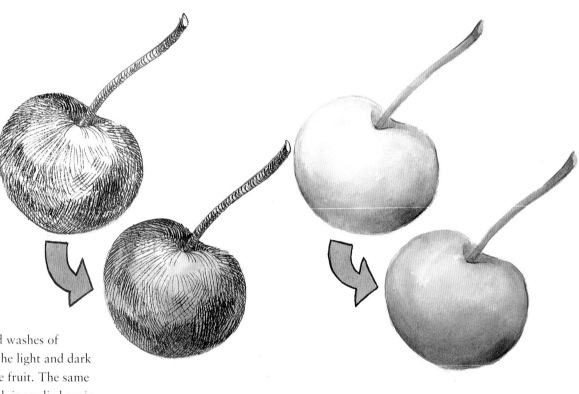

Step 1

Lightly sketch out the geometric shapes of the composition, allowing the shapes to grow and interlock naturally. Find structure and simplicity in the seeming chaos. For example, the flower mass in the foreground at first may seem a jumble. Carefully consider their alignment and you will start to see that they make up a bowl-shaped mass, which is sketched in very lightly. This now helps enormously when placing individual flower heads and stems.

Step 2

Create a brown ink mix, from black, red, and yellow. You could simply purchase brown ink, but by creating a mix, this can be biased toward the cool or warm end of the spectrum. The more black you add, the denser the mix, but also the duller, it becomes. Here the mix is kept constant throughout; on the other hand, you may prefer to change the color and/or density for greater variety or to cool the line into the distance, thus suggesting aerial perspective. The line is applied using the back of the pen point of a reed pen. This fluid line skates lightly across the paper and is a joy to use.

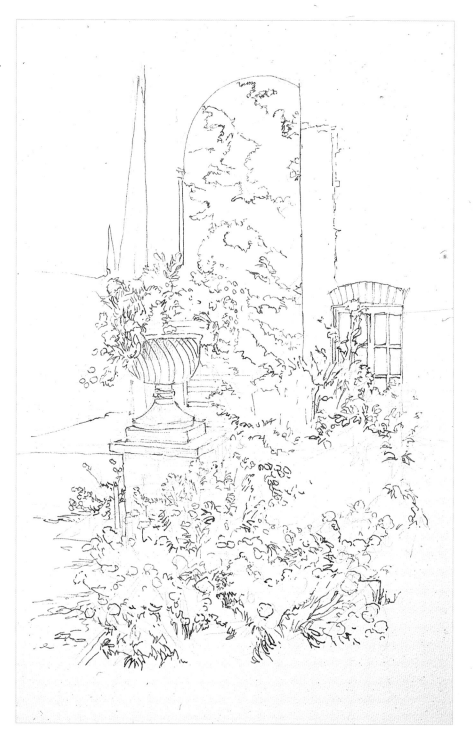

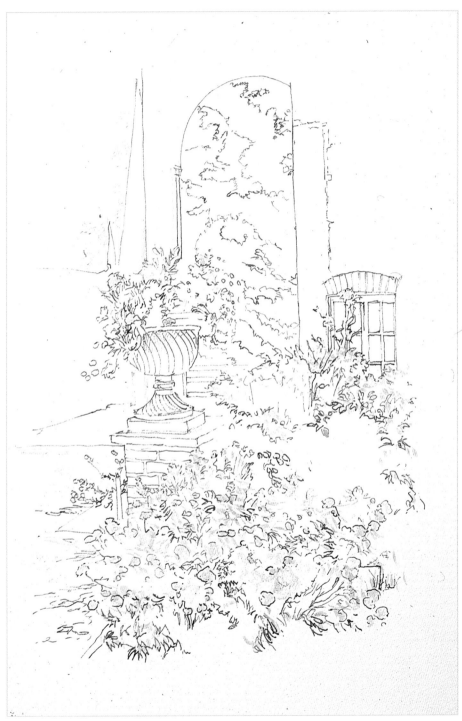

Step 3

Use a kneadable putty eraser to clean off the pencil lines, which would otherwise dirty the color. Although the pencil masks may seem light against the ink, they can confuse if left in place. Considerable masking fluid resists were applied to secure the bright sunlit flowers and leaves against strong shadows. Without such strong contrasts, sunlight will never appear. Begin with the flower heads first, to avoid confusion, and then apply areas for the sunlit leaves. Areas of mask that become over heavy, such as that applied to the background wall, can be gently rubbed open with a finger. Try and be as varied with the rhythm and strokes when applying the masking fluid, as you would when brushing color on highlight areas.

ARTSTRIPS

STEP 1: Main mass of flowers grouped into "bowl" shape...

...on which to place individual flower heads and leaves.

STEP 3: MASKING First mask flowers to identify positions of these important color accents.

Then mask less important leaves, which are to be subsequently sunlit.

Step 4

The first layers of color separate areas, solidify shapes, and eliminate all of the white paper. Although these colors look quite strong against the white paper, they are no match for the line. You may feel that the odd touch of white is required, but remember that you already have white, which is the white of the paper that is protected by the previously applied masking fluid. It often helps to excite the eye to have the odd pure white highlight. Using the three pan primaries and the No. 12 round brush, lay areas of color swiftly. Note the color changes within each wash, made possible through pan mixing. Use a round brush with a good point that can carry the washes into small details as well as block in the larger masses. The masked leaves of the foliage will provide the yellow of the sun's light, so keep the present mix mid to blue-green for shadows.

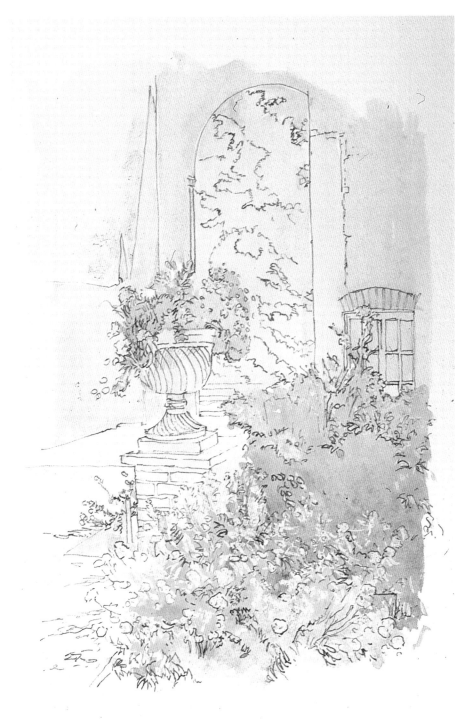

Step 5

[A] Bold wide areas of dark wash bring the painting to life by providing a contrast against which the lighter areas can shine.

[B] Areas of detailed mask allow the large dark washes behind to be applied with speed since the necessary highlights are protected.

[C] Ink linework still easily visible against even the darker of the washes. Wash values are controlled by this essential factor, ensuring watercolor remains transparent.

[D] Greens are mid yellow-green, to blue-green at this stage. The really bright yellows and yellow-greens that will indicate a pure sunlit highlight will be painted over the presently masked areas of leaf.

[E] This foreground mass is light and airy because its silhouette has many "bays" and "inlets," which puncture any possible solidifying of form.

[F] Shadows play an important compositional role in breaking up large areas into more interesting shapes.

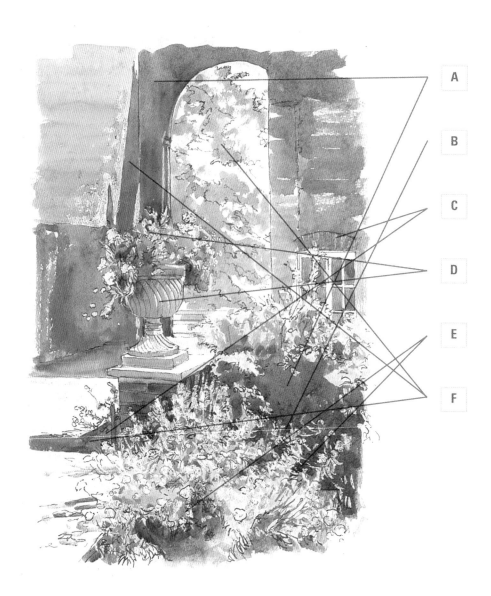

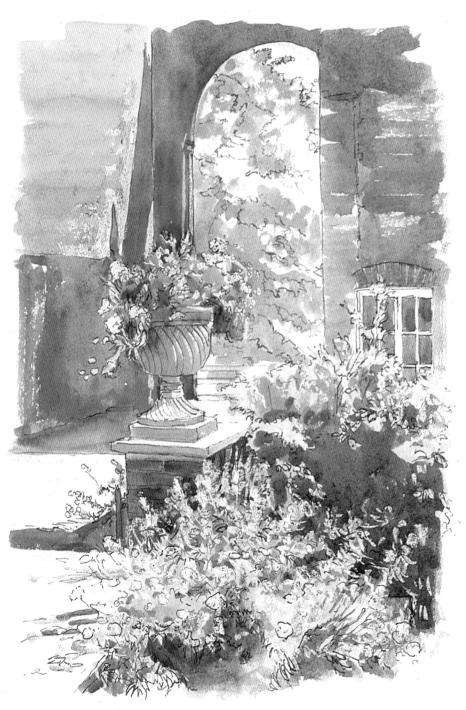

Step 5

Move on to the smaller No. 10 brush to swiftly block on darker washes to the dry surface - guided, but not controlled by the ink line. Evidence of brush strokes is left boldly on the walls to suggest the rough surface of brickwork. Once you have applied the colored wash on the wall below the plant pot, lay stiffer, more solid color into the still-wet surface. This ensures the brick textures fall behind the more important focussed plants in front. Carefully note how contrast is laid against other areas of foliage - left hand edge of plant pot and dark green behind the masked foreground flowers. Although we are describing detail, the washes being applied are bold and wide. Much of the detail is of masked strokes applied earlier. Ink linework is still very much in evidence and the variety of mask and stroke is as irregular, divergent and distinctive as the imagination can conjure.

ART TECHNIQUES FROM PENCIL TO PAINT

ARTSTRIPS

STEP 4: PAN MIXING
Pre-mix fluid washes of red (Ro+Rp), Yellow (Yellow Ochre or Yo+ro+bp), Blue (Bp)

Use final well for mixes of the three...

...bringing other colors into the mix.

Color change now swiftly accomplished within the laying of each wash.

Step 6

Remove masking fluid with kneadable putty eraser. Be prepared for surprises, mostly pleasant, but with the odd shock as is normal at this stage. Now is the time to sit back and assess the whole image before adding the finishing touches. It is so easy to just go on fiddling, but the end of the painting must be dramatic and swift. Look for the problems first. The right hand side of the arch at the rear has a vertical that leans. Masking to the left of the shadow on the back left hand wall is too sharp. These must be corrected first before we can move on to the pleasurable areas, such as adding the color to flowers and leaves.

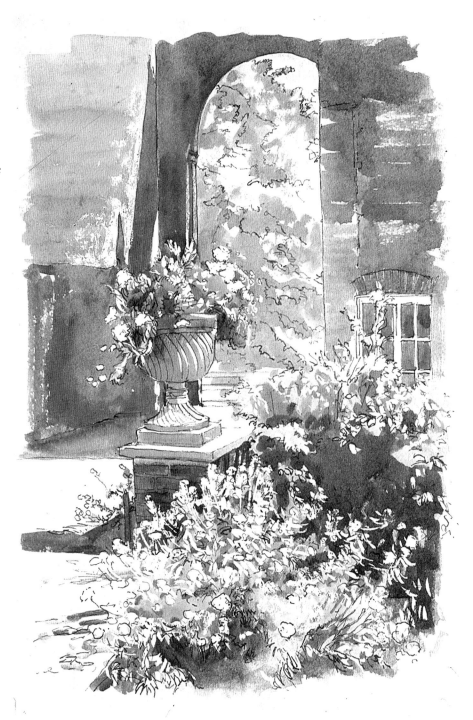

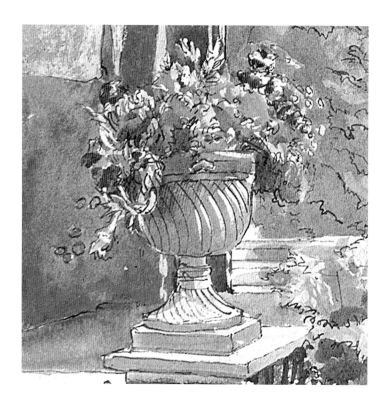

A large, flexible round brush can gently lay a color wash around a complicated detail. This is especially useful when working over previously laid areas of color, as any rewetting must be swift and smooth so as not to disturb any of the underlying layers.

Before edges can dry, use the point of the brush to carry the color into the complex silhouette. As your confidence grows, your speed of application will increase, and you will be able to deal with progressively larger areas of silhouettes such as these.

Step 7

The two problem areas highlighted in Step 6 are immediately overcome by adding a graded wash across the background. This moves from yellow-orange on the left hand wall, which mutes the problem edge of the shadow. As it moves right, it eventually is turned to a strong Ultramarine. This is allowed to overlap the vertical wall edge, correcting the lean. Look at how this same blue creates a wonderful contrast against which the foliage can shine. Using the large No. 12 brush, ensured this was laid swiftly over previous dry washes, with the minimum of disturbance.

Turn to the smaller No. 10 brush to render the scuffs and dabs of color to the gravel on the left hand side. Finally, the flowers: the smaller No. 8 brush is used, mixing color in the brush tip rather than employing large fluid mixes. This allows for rapid color variation. With the leaves, concentrate on adding yellow into the mixes to introduce sunlight. A final wash of dull green over the tree in the distance flattens it, and in so doing, accentuates light in the foreground.

W A T E R C O L O R S

Introduction

The nature of watercolors, which are at their best when used swiftly and fluidly, brings them to the fore as arguably the ultimate sketching medium; not to mention a relatively inexpensive one.

From only a few tubes of color, you can create a multitude of mixes. The surface on which they are worked is relatively inexpensive, and since they are let down with water, no additional outlay on extra mediums to ensure a successful outcome is needed, furthermore, the universal popularity of watercolors ensures a vast range of materials from which to make choices based on quality and cost.

The range of techniques in watercolor is so vast that once you have explored various options, it is possible to work in a specific area that best suits your taste and abilities. No wonder they are the principal choice of beginners, and continue to prove satisfying and ever surprising for the more advanced painter. To introduce you to a reasonable overview of the possibilities for sketching, the exercise in this section deals with two of the most important techniques within watercolor.

The Wet on Wet technique involves working into a wet surface; it always sounds intimidating to the uninitiated. However, once you get to grips with it, the technique provides beautifully soft colors and strokes, which are inimitable in any other medium. The technique of Wet on Dry, that of working onto a dry surface, sounds safer. This technique does however create sharp-edged strokes, that need to be kept buoyant and fresh.

The best watercolor paintings are the result of controlled accidents — when the artist knows where he or she wants to go, directs the brush in the right direction, and then allows the paint to flow.

While this may appear a little reckless, it means the art of using watercolors never fails to challenge, surprise, engage, please, and occasionally disappoint the participant.

Should you be approaching watercolor as a relative beginner, don't be worried that you do not yet possess the speed and fluidity of the more experienced painters. They developed their ability over time, and through experience gained confidence — and like me made mistakes in their beginnings.

You too must be prepared to make mistakes, and your confidence will grow only through practice. How else will you understand how paint will flow and how to control and exploit this flow unless you have allowed it to do so on more than one occasion?

Sketching with watercolors is about taking chances. It is about not worrying over the finished result, but simply to enjoy getting there. Watercolor depends on taking chances, how the colors flow, and how the colors and texture change and develop as the surface dries. It is not difficult to see the affinity of the medium to sketching, and all you need is to jump in and discover this for yourself!

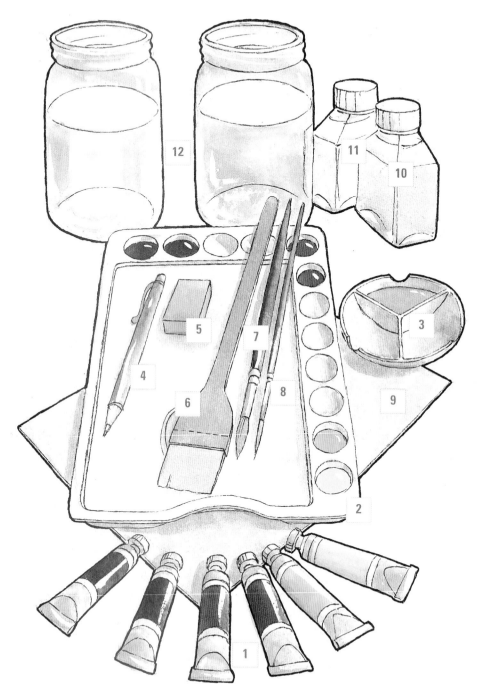

Materials

1. Watercolors in Tubes
2. Plastic Palette with flat area for mixing and wells for storing paint
3. Ceramic Tinting Saucer for masking fluid
4. 2B Automatic Pencil
5. Kneadable Putty Eraser
6. Hake Brush
7. Round Brush Nylon/Sable
8. Rigger Brush Nylon
9. Watercolor Paper
10. Masking Fluid
11. Permanent Masking Fluid
12. Water Pots

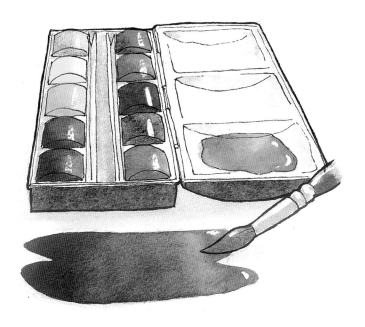

Pans or Tubes?

BOXED PANS

For
- Multi colored washes easily created
- No opening & squeezing tubes, color ready to go
- Mixing benefit — fast color changes for small details
- Lid seconds as a palette
- Robust and easily transportable, often with brush
- incorporated in box
- Some boxes carry extra palette and some a water pot.

Against
- Metal boxes can be expensive
- Pans can easily become soiled with other colors
- Artists' Quality paints necessary for fast dissolves into washes (therefore more expensive)

TUBES & PLASTIC PALETTE

For
- Fluid paint used with little water creates dense dark color wet-on-wet
- Paint already fluid, swiftly creates large washes
- Large palette area for several mixes
- Versatile, suits all watercolor techniques
- Palette light to hold over long periods
- Choice of more economically priced paints (Students' Quality) up to most expensive (Artists' Quality)
- Colors separate in wells, reduces cross-soiling

Against
- Plastic palette can be fragile and difficult to transport with wet paint
- Tubes can dry out when not properly sealed

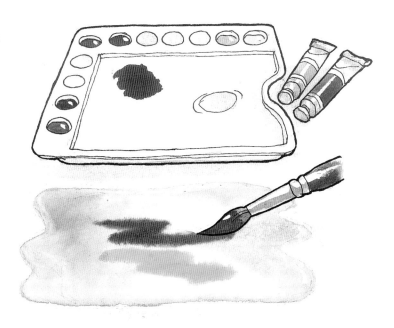

Hints & Tips

HOW THE SUN BEHIND AN
OBJECT CASTS ITS SHADOWS
Diagram 1
The sun's position and our eye
level determine the length and
position of the shadows cast by
the upright poles. Construction
lines are made from the sun
(vanishing point of light), which
pass through the top of each
pole and beyond (orange lines).
A line is dropped vertically from
the sun to the horizon (eye
level). From this imagined point
(vanishing point of shadow),
lines are drawn through the base
of each pole and beyond (blue
lines). The point at which the
orange and blue lines intersect
determines the shadow length.
Once you become familiar with
this technique, you will find it
unnecessary to draw out the
positional lines.

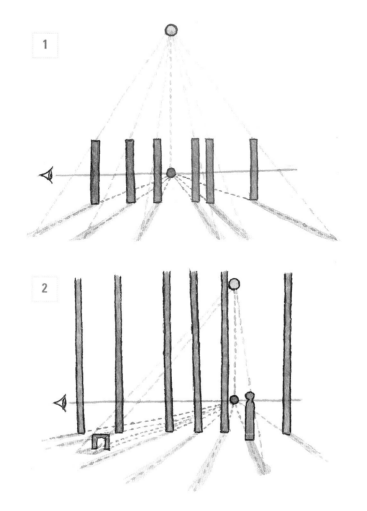

Diagram 2
This is more representational of the composition in the following
exercise. The lines form the sun cannot be taken through the top of
the trees, as they are out of the picture. However, lines from the
vanishing points of shadows (directly below the sun) still show in
the direction of the shadows. The dog and figure shadows can be
constructed, but normally you would use your eye and your
knowledge to judge their direction and length.

Materials

Well-sized Watercolor Paper -
Hot Pressed or NOT

0.5mm 2B Automatic Pencil

Ceramic Welled Palette

Plastic Palette

Six Primary Watercolor Paints
in Tubes

Round Nylon/Sable Watercolor
Brush No. 8

50mm (2") Hake Brush

Nylon Rigger Brush No. 3

Masking Fluid

White Candle

Permanent Masking Fluid

Kneadable Putty Eraser

Step 1

Stretch paper on board and allow to dry thoroughly. Lightly sketch in proportions of the composition. While detail is avoided, the placement of trees is of paramount importance at this stage. Irregular spacing of the trees will guarantee that the row does not become a barrier, but a segmentation of the panorama beyond. The two focal points, the woman and dog, thus become stops along the base line of the trees. The angles of the shadows lead the eye toward the figures and on into the distance.

Step 2

Place masking fluid around the position of the sun. This will not only protect the white of the paper as a highlight, but the strokes begin to suggest the structure of the fine branches against the light. Touches of mask to dog and figure also show where they might catch and reflect light from the sun. Both woman and dog will eventually be silhouetted against this light. These highlights will ensure the figures are not seen as flat, but as three-dimensional objects.

Create fluid wash mix with plenty of water.

Squeeze excess from brush by pulling out of wash, along palette surface. Then pull across palette edge to remove even more.

Prewet stretched paper with generously loaded Hake or largest brush you possess.

Insert color into water layer. Pressure on brush increases amount of pigment deposited.

COLOR REFERENCE

Red-purple (Rp)
Red-orange (Ro)
Blue-purple (Bp)
Blue-green (Bg)
Yellow-orange (Yo)
Yellow-green (Yg)

COLOR MIXING

Where the prefix letter is shown in capitals this denotes a larger quantity of that particular color.
Conversely, where the prefix letter is shown in a lower case, this denotes a smaller quantity of that particular color.
E.G.
Bp= large amount of blue-purple.
bp = small amount of blue-purple.

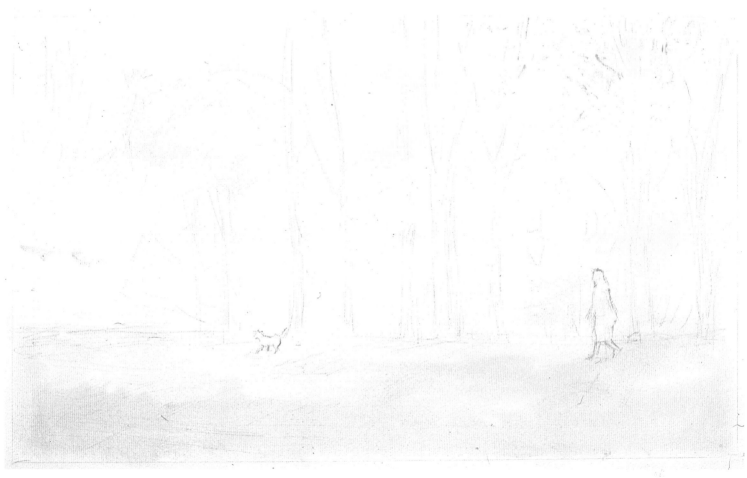

Step 3

The first broad washes not only eliminate the stark whiteness of the paper, but also spread the gum in the paint as a fine layer. Subsequent layers will be much easier to lay, since the surface tension will have been diminished. On certain papers, especially those that are well sized, the first layer of wash may at first be resisted. This effect is known as pig-skinning, because if left to dry, it creates a quite definite and individual texture. Working wet-in-wet eliminates pig-skinning, as the surface can be flooded with water if necessary, provided the paper has been stretched. Various yellows and yellow mixes have been used here. Toward the area occupied by the sun lemon yellow (Yg) provides intense color. This moves through Cadmium yellow (Yo), which is then dulled with a little purple (Bp+ro). The ground is a simpler gradation of Cadmium yellow (Yo) to dull yellow, with added purple.

NOTE: Yellow ochre provides an alternative to adding purple to yellow. Allow this stage to dry thoroughly before moving on.

Step 4

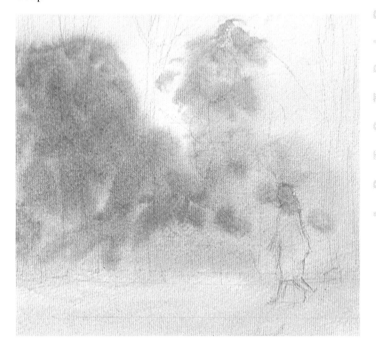

ARTSTRIPS

Stiffer mix created by adding less water.

Draw loaded brush head across palette surface to re - shape round brush head.

Used flat on to wet surface, this re shaped brush makes broad strokes.

Used edge-on, it creates fine lines and strokes.

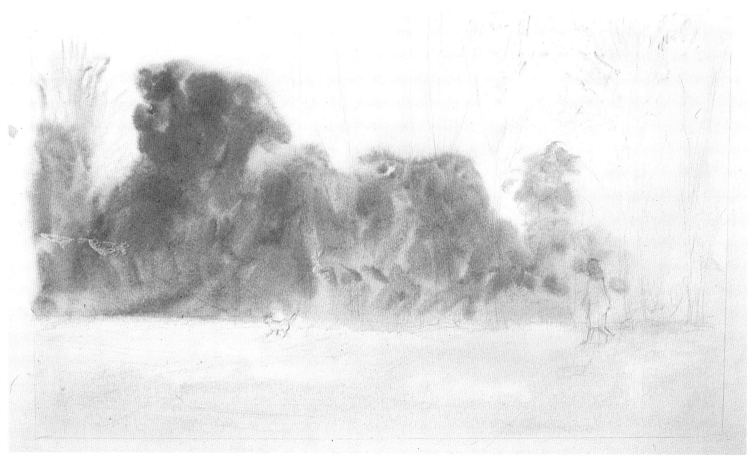

Step 4

Sunlight is yellow, and as a consequence, areas of shadow tend to have a bias toward its complementary or opposite color, which is purple. As the yellows present in the composition move from primary yellow to orange-yellow, the shadows can move toward a blue-purple. Rewet the area of distant trees and render using a slightly stiffer mix than was used for the yellows. The trees against the sky create an almost solid silhouette, make sure that the edge of this silhouette is full of interesting shapes, bays, and inlets. Not only does the tree silhouette then catch the eye, but also the yellow sky beyond forms interesting negative shapes as it impinges on the purple mass. Simply paint through the figure and the dog at this stage, as they are to form even darker solids against the brightness of the sky, since they are closer. Leave to dry.

Step 5

[A] Masking fluid can be seen through the colored washes. Those around the position of the sun allow a great deal of freedom when applying the stains of the twig masses, since you know that the bright values of the sunlight are protected.

[B] Flat strokes produced by the shaped round brush.

[C] Edge-on strokes produced by the shaped round brush.

[D] The irregular placement of the ground shadows leaves interesting negative shapes of sunlight. Irregularity in nature is natural, but you must concentrate to achieve it, for our brain constantly seeks regularity and tries to force us to create regular patterns. You need to avoid this.

[E] The same variety must be applied to brushstrokes. Vary the thickness, strength, and direction as much as you can.

[F] Blue-purple suggests distance (Bp+rp).

[G] Red-purple implies closeness (Ro+bp).

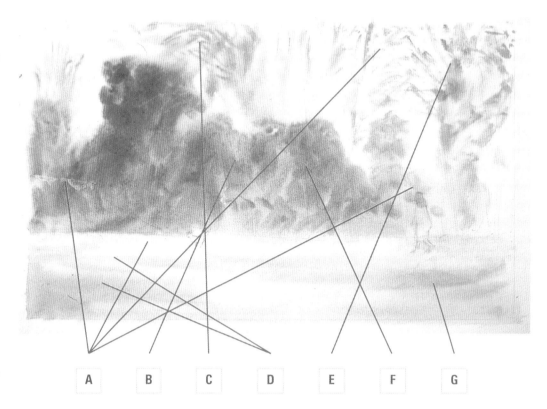

A B C D E F G

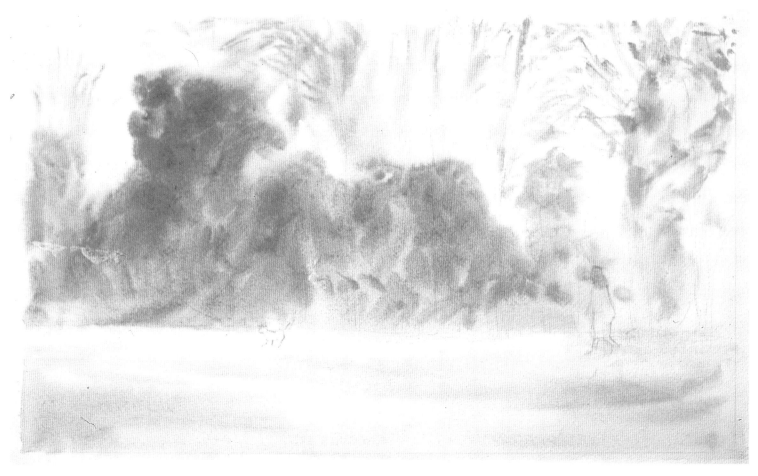

Step 5

The trees directly behind the figure, between it and the distant purple trees, form a barrier. However, we must be able to look through this barrier with ease, in order to engender a feeling of depth and light. For this to happen, the trees must be kept as soft as possible, for as long as possible. The fine branches of these trees can begin as a soft stain against the sky. Give these stains rhythm and movement to suggest the growing structure of the twig masses. Painted wet-on-wet, they begin around the position of the sun. The color mix here is still purple, but is now a red-purple to suggest that they are closer than the blue-purple distant trees. Use Cadmium red (ro) in the mix to achieve this warmth. The same color is used horizontally, wet-on-wet, across the foreground to begin to establish its irregular surface. Allow to dry.

Recession & Depth

Soft Focus

Achieved by painting one rectangle wet-on-wet, against its similar counterpart painted wet-on-dry will suggest that the softer rectangle is further away.

Overlapping Planes

When the rectangles overlap, our eye tells us that one is moving behind the other. This illusion works for more complicated shapes, as well as these simple rectangles.

Color Temperature

The cooler the color, the greater its distance seems. Our eyes are used to distant objects seeming bluer. Most color is leached out as it travels through the atmosphere, but blue can travel the most distance, hence our blue skies.

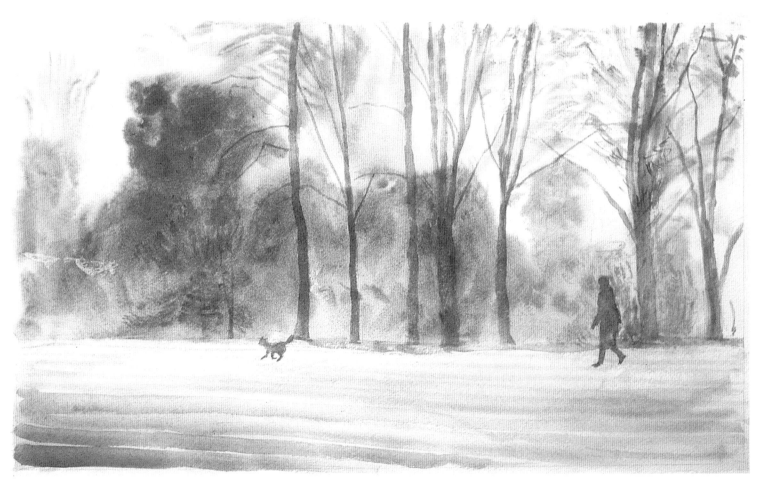

Step 6

Wet-on-wet work could continue beyond this point, but as this study is a sketch and the main elements are the figures and the trees directly behind, it is possible to begin focusing on them now. These are painted wet-on-dry, which provides them with sharp edges on which the eye can fix. Begin with the trees and work from the back to the front so that shapes can overlap. The strength of wet-on-dry, provided by its sharp silhouettes, means that the colors can be a little gentler in value. The trees are a mid-strength purple. Drag an almost dry brush around the base of the trees to begin to suggest the undergrowth. Paint the figure and dog solidly, using a very warm purple-red. The foreground is painted in bands that follow the contours of the ground, adding more water into the distance and reducing the thickness of the stroke to suggest depth.

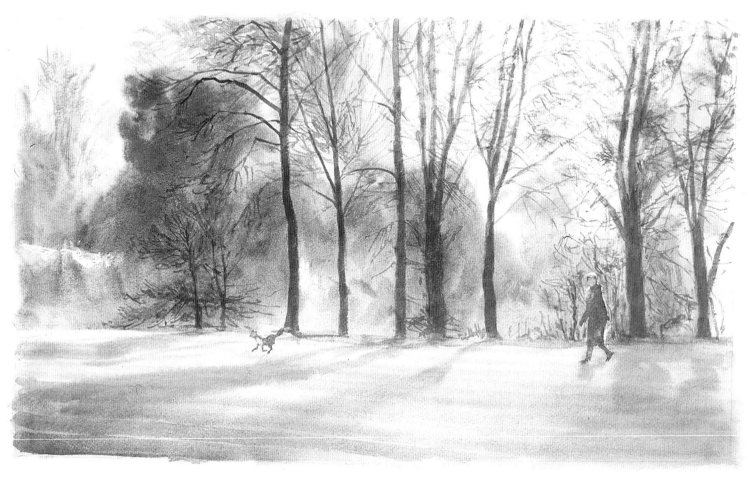

Step 7

Remove masking fluid throughout with a kneadable putty eraser to reveal white highlights. Some of these masked highlights will inevitably prove too sharp. Soften edges where necessary, using a damp brush, and then lift color off with an absorbent tissue. Use the rigger brush to apply the fine, focussed branches of the trees.

The lower tee trunks should be scuffed or stroked with color, using the round brush. This is applied to increase the contrast with the background and to bring texture to the surface of the trees. This color is allowed to become cooler (add Bp) the further it is from the sun. Shadows, by their nature, need to be soft-edged, so they are

applied using the final piece of wet-on-wet across the foreground. The wetting that is necessary also softens the banded colors previously applied, thus softening the focus overall.

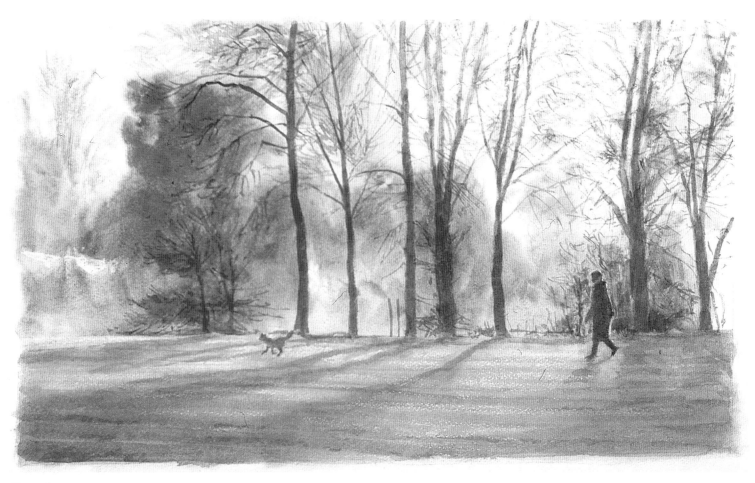

Step 8

FINAL TOUCHES & LATE MASKING

Apply a warm yellow (Yo) to the highlights on the figure and dog, and once dry protect with permanent masking fluid. No close encounter with nearby finishing touches can now eradicate them. Wax resists are laid on the foreground and worked over with purple wash. They are again used in the undergrowth below the trees where they give a textured resist to washes suggesting leaf and branch. Harsh resists around the suns position are softened with a thin wet-on-dry wash of yellow (Yg), adding a little blue (Bp) further away from the light source. With the permanent resists in place, the figures can be strengthened with blue-green (Bg) washes, which really separate them from the warmer colors all around. Finally, the strength of the shadows is increased slightly, before a dull yellow (Yo+bp) graded wash applied across the background shows up the wax resists more strongly.

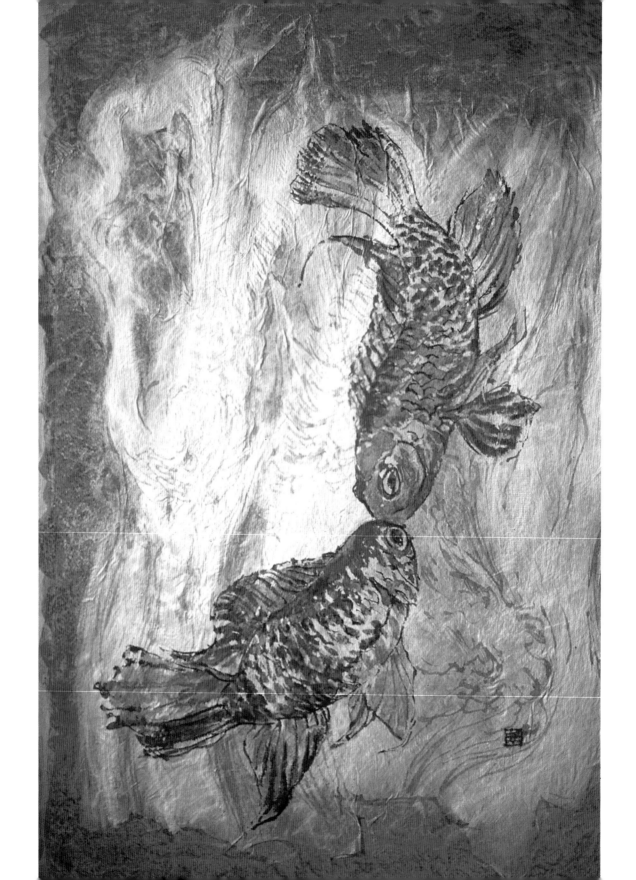

MIXED MEDIA

Introduction

Mixing media will provide a new insight on materials when you begin to combine their positive qualities to create something quite new. Unfortunately, it could also provide an excuse for going so far with one media in any one composition, dropping it when you run out of ideas and slapping something on top that you hope will work. But this approach could be fraught with frustration.

It is best to work within the limits of one media until you fully understand its nature; then by all means try another and familiarize yourself with its idiosyncrasies. At this point consider how each could work with the other, taking particular note of their individual weak points. Can one media be bolstered by another to produce a strong combination?

The exercise featured in this section is worked in a variety of media.

CHINAGRAPH

Chinagraph is a waxy pencil that resists water-based media. It provides a dense line, which can be soft with gentle pressure or more demanding when applied more vigorously. Since it resists watercolor, it is excellent for the line and wash technique, where the line must remain dominant against even the strongest wash. Its dominance can, however, also be a

disadvantage. What if the line is required to play a secondary role, even to the point of beginning to disappear against the influences of a strong color?

GOUACHE

Gouache is an opaque watercolor, that is often termed a designer's color. It's strength lies in its opacity and even coverage, when used in a cream-like consistency. It can be used much more fluidly, as with watercolor, but being opaque, it never achieves the same luminosity. When used on colored paper, however, the opacity comes into its own, as it can then be seen in full glory against the surface. Being a water-based medium, it will be resisted by the chinagraph. However, as the density of the color mix is increased, it will eventually match the resists of the chinagraph, and at full strength will cover the line.

Since the medium dissolves in water, underlying layers can be disturbed and have a tendency to bleed through. The natural antidote to this occurrence is to gradually stiffen the mix as layers are built, thus excluding more and more water. Since this goes hand in hand with the requirement to overpower the line, the process is a natural one with the two media working well together.

PASTEL PAPERS

These come in many colors and in a variety of textures. As their name suggests, they are designed for use with a dry medium. Generally, they are prone to cockling when wet and therefore require stretching if they are to be painted on. A quick dip in water and fixing to the drawing board with gum strip will suffice.

Being quite absorbent, applied paint will dry swiftly, a characteristic that suits the use of gouache well since swift drying ensures the minimum of disturbance to paint layers.

This exercise demonstrates that three elements, which at first seem disparate, will combine well, given that their qualities will benefit each other — thus producing an ideal mixed media technique.

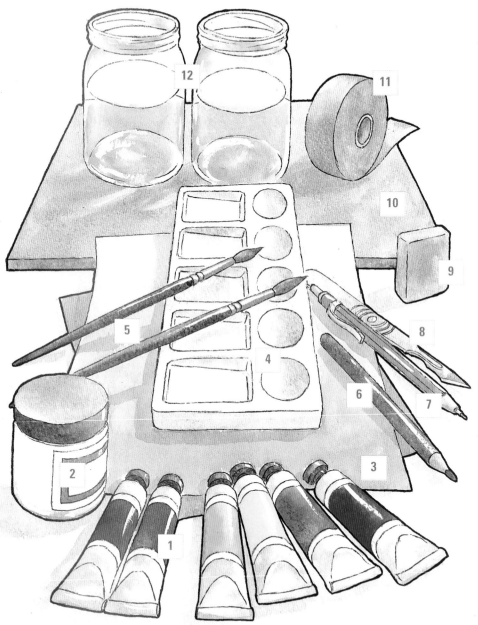

Materials

1. Tubes of Gouache Paint
2. Large Pot or Jar of White Gouache (also available in large tubes)
3. Colored Sheets of Pastel Paper
4. Ceramic Palette (gouache colors can stain plastic)
5. Round Brushes
6. Chinagraph (also termed china marker or glass marker)
7. Automatic Pencil 0.5mm 2B Lead
8. Sharp Knife or Scalpel
9. Kneadable Putty Eraser
10. Drawing Board for stretching paper
11. Gum strip for stretching paper
12. Water Pots

CHINA MARKERS

These can feature a peel off sleeve in which a thread hangs close to the end, which when pulled tears away the sleeve in strips. This enables you to control the length of marker to be revealed. The marker lead is soft, and being able to peel away in small sections like this helps to prevent breakages. If a wooden shaft covers the marker, this can be similarly pared away with a sharp knife or scalpel.

Only pare away the wood, leaving the blunt point revealed. It is of no value to sharpen this point, as it is soft and soon wears down. The point is kept sharp in the manner in which it is handled, as shown in the diagram on Page 92.

LAYERING GOUACHE

Working from left to right, this diagram shows the typical layering of gouache. On the left you can see that the first layer may be applied wet-on-wet, creating soft areas of paint. Typically, this first layer is the darkest. As we move to the right, the layers become less fluid. Each is allowed time to dry before being overpainted. The final yellow-green has just enough water added in order to allow it to flow evenly. By working in this manner, the least disturbance occurs to overpainted layers thus the chance of bleed-through from colors beneath is less.

Hints & Tips

USING THE CHINAGRAPH

This pencil marker draws with a wonderfully dense, yet soft line. As it is too soft to effectively sharpen, you must employ tactics that will enable the line to be as descriptive or variable as possible. Working from left to right on the diagram, the marker starts with a blunted point. When angled against the surface, it wears down on one side, giving a very broad line. When rotated, a sharp edge can be utilized to draw a finer line. Rotate frequently and a point is formed, which can be used for areas of detail. This will eventually blunt, at which point the process should be repeated.

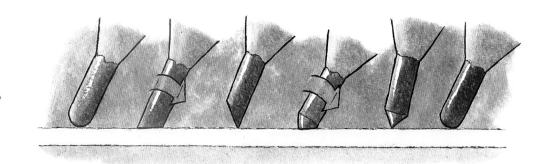

While this regime may appear a little formulaic, it does demonstrate that you can exploit the various results created as the pencil point wears down and as you adjust its angle to the surface. Over heavy pressure need not be used to produce a suitable density of line, and if the pressure is too strong, the point will break. The very softness of the lead and the necessity to use controlled pressure makes the line sensitive to the surface texture of the paper used. Try various textures of pastel paper until you find one that suits both your temperament and the demands of the subject.

MATERIALS

Colored Pastel Paper

0.5mm 2B Automatic Pencil

Black Chinagraph, China Marker, or Glass Marker

Ceramic Palette

Six Primary Gouache Paints in Tubes (plus White)

Round Nylon/Sable Watercolor Brush No.s 6, 8, & 12

Kneadable Putty Eraser

Step 1

Stretch paper on board and allow to dry thoroughly. Work out the subtle relationship of leaf, flower, background, and the rectangle that contains them, by lightly sketching in using the automatic pencil. Keep sketch scribbly and loose and remove any mistakes with the kneadable putty eraser. It is essential at this stage that you are satisfied with the positioning of the elements within the composition.

Step 2

Overwork the pencil scribble with the definitive line using the chinagraph. Make it as descriptive and variable as you can. Alter not only the angle at which the pencil meets the surface but also the direction in which the pencil is drawn. Be as flexible and as fluid with the line as you can manage. The pencil line will now be diminished in comparison to the chinagraph. You may wish to remove it, either because it offends or to prevent the graphite from causing the paint layers to look dirty. Do so gently, using the kneadable putty eraser.

ARTSTRIPS

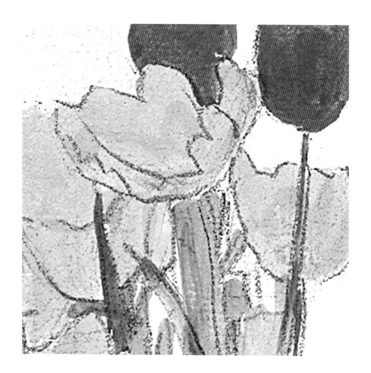

Thinly, but solidly, block in dark washes of undercolor.

The colored paper allows white to be used as a color.

Paper color allowed to show provides a soft, textured highlight — warm or cool, depending on paper's color.

The graphite pencil disappears, but the chinagraph shows through easily.

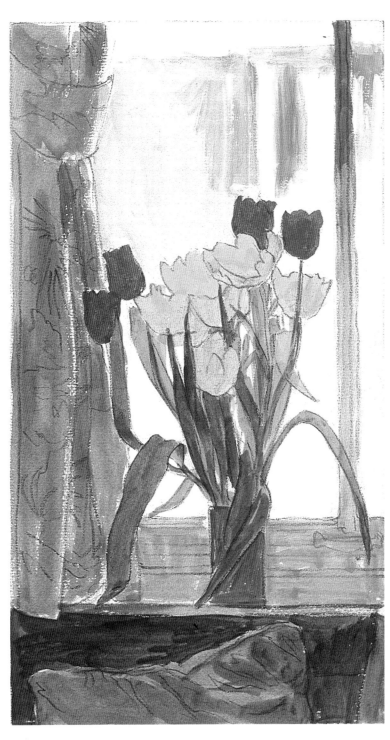

Step 3

Begin at the top of the picture with the blue and white seen through the window. This is the negative space of the composition and interacts with the solid silhouette of the flowers, seen against the light. Keep other washes simple and dark. You are separating the image into color families, but don't worry too much about accuracy at this stage. You can work into the wet washes with darker colors as you begin to get the feel of the tonal balance and what the surface will take. It is quite surprising just how dark you can go, but you will only find this out as the colors are applied and interact with one another and the surface. Begin with a large (No.12 if possible) brush for the main washes, but go slightly smaller for the leaves. Pull the brush in the direction of the leaf, varying pressure and twisting to achieve flowing effects. You must be positive with these strokes. The paper is absorbent and the color will sink in quickly. Over fussing will lead to unpleasant, over heavy brushwork, so loosen up your wrist.

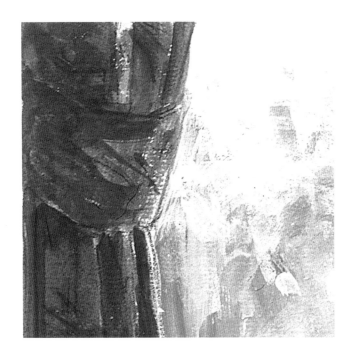

Smaller brushes and stiffer paint will bring drier textured strokes into play.

These create vigorous visual texture to excite the eye.

Too hard edges may not lie well with other colors.

Rewet dry color with large soft brush and allow to partially mix or soften naturally with underlying color.

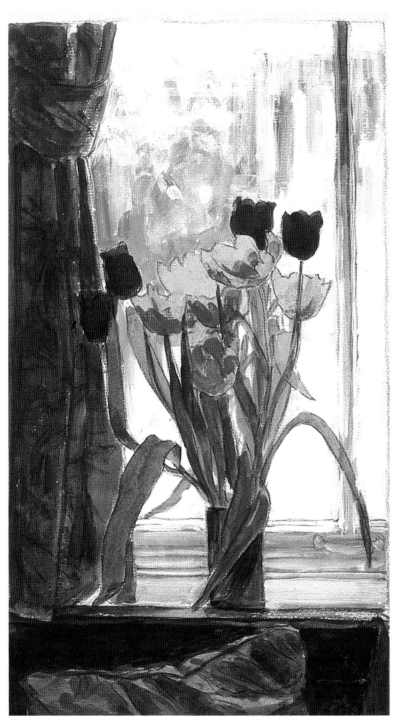

Step 4

Having covered the surface in the previous layer, the balance of values now begins to be assessed and adjusted across the whole composition. To achieve the sense of light, which now begins to appear, contrasts in these values must be achieved. Look, for example, at how dark the red tulip on the right appears against the light values all around it. This appears to fill the window with light. Ordinarily, complementary colors in the flower mixes would be avoided, as these dull what are meant to become dark yet intense petals. Here, however, complementaries can be used, since they are to be painted over with semi-opaque layers that will themselves be more intense. Creating dull darks and overpainting with bright layers can be exploited in all watercolors, but it is much more effective when the overlaid layers have some degree of opacity. The extra darks on the curtain, wood, and cushions below give us one end of the tonal scale. In the window, extra white in the mixes pushes the values toward their lightest.

Step 5

Working with the smaller brush, work in both warm and cool lights to the leaves. Light passing through a leaf is very yellow. When reflected off its surface, however, it is the color of the sky that we see, hence the blue reflected lights. They have to be placed swiftly in one deliberate stroke, so as not to disturb underlying color. Inevitably, as you work toward lighter colors on top of the strong pigments of the flowers, some of the color will bleed through from beneath. This is a natural element of layering gouache, and you must incorporate it into your technique. Take care of the color in the brush itself. As you create the lighter mixes, previous colors tend to cling to the brush hairs and soil your efforts. Clean brushes thoroughly between mixes to avoid frustration.

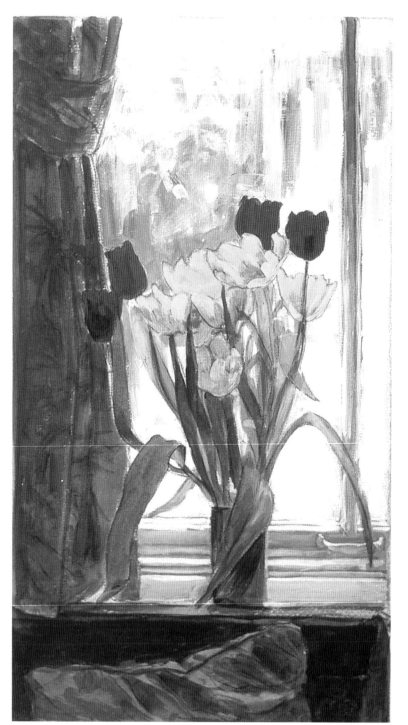

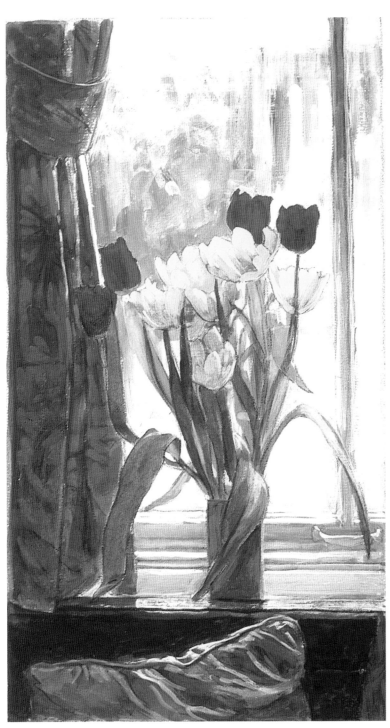

Step 6

It never ceases to fascinate me how the highlights, small as they are, can bring strong light into an image that has so many large dark areas. The darks do of course provide the essential contrast against which the lighter colors can work, but there is more than this at work here. The fact is our eyes seek out the highlights to tell us the color of an object and how well lit it is. We often ignore the dark areas of shadow, only returning to them once we have fully inspected and wrung out all information from the highlights. Here the highlights are visited upon the curtain and the wooden window sill. Note how the paint is scuffed along these to give the sense of texture, both of cloth and wood. Blue-white highlights enhance the leaves, while yellow-white and red-orange is stroked onto the petals of the tulips.

Step 7

[A] Extreme tonal range form light, through medium values to dark, guarantees a painting full of light.

[B] Dark values against light and vice versa (counterchange) provide the maximum contrast possible, further enhancing the painting's internal light.

[C] White used as a color against the colored pastel paper.

[D] Dry, scuffed lights suggest a hard texture.

[E] Blue reflected lights.

[F] Light passing through the leaf brings out the green of the leaf, but adds yellow from sunlight.

[G] Final lights far outmatch their size in the order of importance in the final painting. Because we see these first, we want to paint them first; but left as the final touches, they are tremendously exciting to execute and observe.

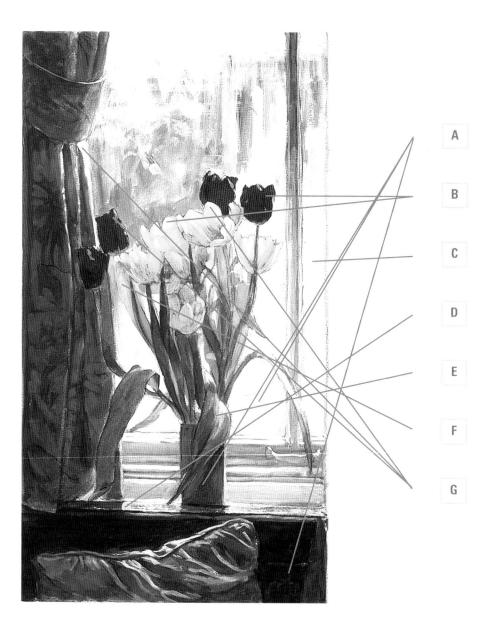

Step 7

The hardest wait of the painting can now be rewarded with the pleasure of applying the final highlights, which are almost pure white. With the curtains and the leaves, a blue-white stroke should be applied. Almost immediately, they are finished with just a touch of white itself. The final white may remain pure or might just accept a little bleed from the colors beneath. Regardless, these are the brightest sparkles of light and are well worth waiting for. You will also see them in the yellow petals, where again they become a light version of the petal color, followed by white itself.

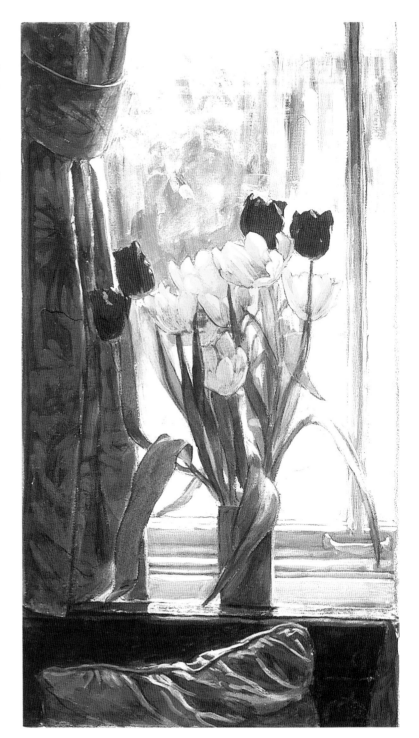

Surface Color Mixing Through Layering and Blending

NOT ALL COLOR MIXING IS PRODUCED ON THE SURFACE OF THE PALETTE; MUCH IS DONE ON THE SURFACE OF THE DRAWING OR PAINTING. The best example of this can be found in the work of the Pointillists. It is fascinating to see how dashes and dots of primary and secondary colors can mix visually to produce a virtual rainbow of colors in their work. At the time, these effects fascinated the artists to such a degree that the color mixing often superceded the subject in the works, producing a static almost stilted view of the world.

To produce a work composed entirely of dots or color is, I can guarantee, terribly boring, for it is no longer a new idea. However, the concept is of extreme importance generally, as visual color mixing can still create excitement for the eye. Certainly one of the most important lessons I ever learned in regard to oil painting was not to over mix colors. On the contrary, brushstrokes streaked with different colors are far more exciting than those that have been perfectly mixed.

How can this idea be employed when working in pencil, pastel, and the water-based media?

Let us consider how colors can be mixed on the painting itself. There are two principle ways in which to go about this: layering or blending. While both may be used in tandem, it is worth looking at their individual effects.

LAYERING

When colors are layered in order to mix them, it is crucially important that the top layer should not entirely overwhelm the bottom. This can be achieved in two ways. Either the top layer may be transparent or, if opaque, it must not entirely cover the surface, which highlights the differences between using transparent or opaque media.

Watercolor is the perfect transparent medium, allowing one to lay a solid layer of color over another with the absolute confidence that light can pass through both layers and hence back from the paper beneath — revealing the layers as a color mix.

Gouache, on the other hand, is often termed "body color" to indicate its solid opacity. Used thinly, it is less opaque, and used in this manner will allow some undercolor to show through. Mixed more thickly, it tends to cover completely and must be applied less solidly to achieve a color mix with the underlying layer. Another consideration is the problem of bleed through. As layers are built, the powerful pigments can creep upward, to be revealed bleeding through, thus affecting the final mix.

BLENDING

This can occur through brushing while the paint is still wet. Alternatively, the medium (glue) that holds the pigment to the surface can be redissolved, allowing the pigment to flow and mix.

Lying colors next to one another to create a visual blend is a further option, although this is where the distinction between layering and blending becomes blurred.

TERMS ESSENTIAL TO UNDERSTANDING COLOR MIXING
HUES
Bright primary and secondary colors are known as hues.
VALUE
Some hues are very light, while others are dark = different values.
INTENSITY/CHROMA
Dull colors have a lower intensity than the bright ones.
TONE
The degree of lightness or darkness of a neutral gray.

Colored Pencil

LAYERING

Hatching and cross-hatching, also known as line texture, are overlaid in differing colors. Here the overlapped colors can be compared to the "natural" or local colors beneath.

Shading, using the shoulder of the pencil point, is layered. Only three colors have been used (see local color beneath), and it should be noted that the order of overlay is important.

Shading and hatching are overlaid to create color mixes. The shading provides a soft cloud of color, which the line texture defines and brings into focus.

Pastels: Dry Sketching

BLENDING

Physically working one pastel into the other creates a blend on the surface of the pastel paper. In this example the surface becomes more and more loaded with pastel until the surface feels slippery, more like paint. This is the closest that a dry medium can come, in its natural form, to a wet fluid medium.

With a less loaded surface, a paper wiper is used to blend the dry pigments together. The pressure required to smear the pigment also releases some from contact with the surface, and this falls away as dust. The result is a thin, semi-transparent blend, through which the paper color and texture is revealed.

A wet brush is used to dissolve the pastel pigments and blend them together. A traditional technique — bolstered by the fact that if a little gum or watercolor medium is added to the water — the pigment is fixed to the surface; the same principle as using a water-based medium. When water alone is added, the pastel turns back into a dry powder, which can be easily removed.

Pastels: Oil

BLENDING

Two colors of oil pastel, blended physically on the surface, are worked one into the other and vice versa until the required balance of pigment was achieved. When more than two colors are used, the mix can start to become a little dirty. It is best, therefore, to keep oil pastel mixes simple.

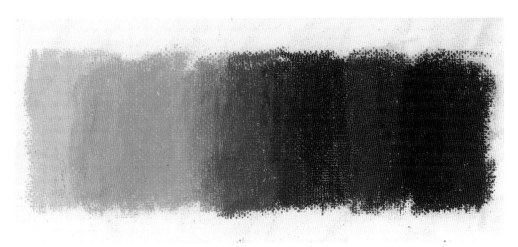

Sparsely laid oil pastel contains a good amount of pigment when dissolved in thinner. Artists' Distilled Turpentine or Odorless thinner is used with a large soft round brush. The result is brushy and can be overlaid with further pastel, either while wet or once dried, yielding differing results.

Heavily laid oil pastel can soon get out of control when dissolved with thinners. A much smaller brush is used to gently blend color for soft focus effects.

NOTE

When using thinners, it is advisable to work on a surface prepared for oil painting such as the oil board used for these examples.

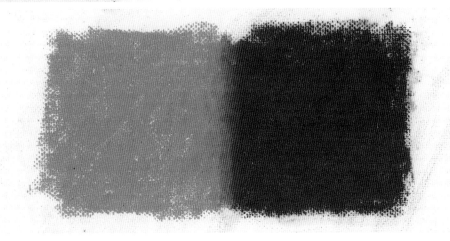

Watercolors: Transparent Medium

LAYERING STROKES

Layering strokes of colors creates color mixes where the strokes intersect. This partial overlapping is fascinating because of the number of colors that are produced. We either see a single color or two or three. This dazzles the eye and is a reminder of all the artists who have used defined strokes of color to build up an image.

LAYERING WASHES

Layers of solid, even color create pure mixes. Having eliminated the white ground, the dazzling effect has gone and we are able to see the color and their mixes more clearly. In this example, the three primary colors overlap to create secondary color and eventually, colored grays. The order of layering does make a difference. In this case blue, then red, then yellow ensures that the final yellow is not overpowered but can be seen lying on the surface.

LAYERING UNEVEN COLOR WASHES

In this instance, blue, once dry, is overlapped by red. The dull purple in the center is a much more dynamic mix than if it had been premixed on the palette. This is due to the change of value, which cannot be exactly matched, and the subtle irregularities that arise are more exciting to the eye.

LAYERING GRADUATED COLOR

A dry blue wash is overlaid with red, but since the gradation is reversed, the central mix creates a change of hue from blue to red, rather than a change of value. Being mixed on the surface, this central section possesses a unique textural quality.

LAYERING TEXTURES OF COLOR

The effects of scumbling color is similar to strokes of color in that it allows white paper to show through, and many colors are mixed from only the three primaries. Color scumbled on the surface is less dense than strokes of color and thus appears to dissolve visually into a more homogenous texture.

EXPOSING LAYERS OF COLOR

Yellow, red, and blue are mixed in layers and in that order. However, each layer is treated to areas of masking fluid, which protects the color in that layer from subsequently applied overlays. Once the mask is removed, the colored layers are revealed. In this example the outline and imprint of a butterfly was protected with the masking fluid. Creating such an image is easier if you start with colors of a light value, overlaying progressively darker colors.

Gouache: Opaque Medium

Blending

Taking such disparate colors as Ro and Bp and mixing in various exercises is a quite a test, being almost opposites on the color circle.

WET-ON-WET

The surface is prewet with a large soft brush (Hake). Stiff color, with little added water, is painted generously on, allowing the colors to mix in the center. The resultant color is quite gray, not just because the colors are so distant but also due to the opacity of the paint.

CUTTING

Two blocks of color are laid next to one another and allowed to dry. Lines are hatched into each color, using a very fine (000) sable brush (red into blue, blue into red.) Slowly, the texture builds up and the join between the colors is effectively stitched together. This fine hatching and cross-hatching is the manner in which Indian Miniaturists build up their shading and volume, and it is this school of painting that refers to this technique as 'cutting'.

REWETTING WITH A SMALL BRUSH

While this seems the obvious manner in which to blend a surface color, it is by far the most difficult. Rewetting the color has a tendency to lift pigment, exposing the light paper beneath. Tickling the paint also tends to make it appear a dirty mix. However, this can be used in small areas, providing it is done with a small, soft brush. In this example the top section of the join was softened, taking the damp brush down the line. The bottom section was completed with the brush going across the line.

Rewetting with a Large Brush

Here is a bold approach: wetting the whole surface with a large soft brush such as a Hake. The subsequent paint movement will be totally out of your control, but it does lead to blending and some exciting accidents, which can be adjusted later. Even the softest of brushes will disturb a little of the paint, as it moves across the surface, delivering the water. This can be seen on the shoulder and back of the jar outline.

Splash Blending

This chancy technique is used much more regularly than you would expect. Water is delivered to the dry paint, vigorously splashed on from a bristle brush. Follow the silhouette of the jar and you will note dissolved and softened edges where the water fell and sharp edges that remained were left to dry and thus stayed hard.

Spray Blending

Using a fine mist from a spray to deliver the water cuts out the surface friction caused by a brush. While there is little irregular paint lift, the two violent colors allow you to see how the edge between the two has nevertheless been blended. At the base of the jar, the paint run is heavier, where the pool of water became deepest, allowing more time for spread.

COLOR MIXING

Where the prefix letter is shown in capitals this denotes a larger quantity of that particular color. Conversely, where the prefix letter is shown in lower case, this denotes a smaller quantity of that particular color.

E.G.

Bp= large amount of blue-purple.

bp = small amount of blue-purple.

COLOR REFERENCE

Red-purple (Rp) i.e Crimson Red

Red-orange (Ro) i.e Cadmium Red

Blue-purple (Bp) i.e Ultramarine

Blue-green (Bg) i.e Prussian Blue

Yellow-orange (Yo) i.e Cadmium Yellow

Yellow-green (Yg) i.e Lemon Yellow

ART TECHNIQUES FROM PENCIL TO PAINT
by *Paul Taggart*

Based on techniques, this series of books takes readers through the natural
progression from drawing to painting and shows the common
effects that can be achieved by each of the principal media, using a variety of techniques.

Each book features six main sections comprising of exercises and tutorials
worked in the principle media. Supportive sections on materials and tips,
plus color mixing, complete these workshop-style books.

Book 1
LINE TO STROKE

Book 2
LINE & WASH

Book 3
TEXTURES & EFFECTS

Book 4
LIGHT & SHADE

Book 5
SKETCH & COLOR

Book 6
BRUSH & COLOR

A C K N O W L E D G M E N T S

There are key people in my life whom have inspired me over many, many years,
and to them I extend my undiminishing heartfelt thanks.
Others have more recently entered the realms of those in whom I place my trust and I am privileged to know them.
Staunch collectors of my work have never wavered in their support,
which has enabled me to continue to produce a body of collectable work,
along with the tutorial material that is needed for books such as this series.
I will never cease to tutor, for the joy of sharing my passion for painting is irreplaceable
and nothing gives me greater pleasure than to know that others are also benefiting from the experience.

I N F O R M A T I O N

Art Workshop With Paul Taggart is the banner under which Paul Taggart offers a variety of learning aids,
projects and events. In addition to books, videos and home-study packs, these include painting courses,
painting days out, painting house parties and painting holidays.

ART WORKSHOP WITH PAUL

Log on to the artworkshopwithpaul.com website for on-site tutorials
and a host of other information relating to working with
watercolors, oils, acrylics, pastels, drawing and other media.
http://www.artworkshopwithpaul.com

To receive further and future information write to:-
Art Workshop With Paul Taggart / PTP
Promark
Studio 282, 24 Station Square
Inverness, Scotland
IV1 1LD

E-Mail : mail@artworkshopwithpaul.com

A R T W O R K S H O P W I T H P A U L T A G G A R T
Tuition & Guidance for the Artist in Everyone